Artistic America,
Tiffany Glass,
and
Art Nouveau

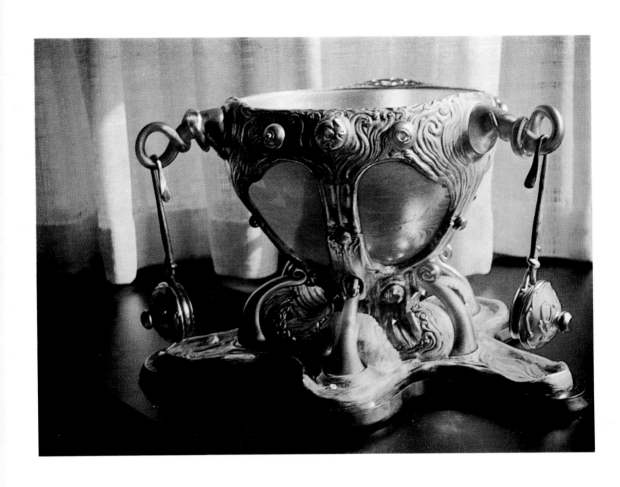

Frontispiece
Louis C. Tiffany, Punch Bowl Made for
the Paris Exposition of 1900.
Robert Koch Photo,
Collection of Dr. and Mrs. Robert Koch.

Artistic America,
Tiffany Glass,
and
Art Nouveau

Samuel Bing

with an Introduction by Robert Koch

The MIT Press
Cambridge, Massachusetts, and London, England

List of Illustrations Compiled by Robert Koch

List of Illustrations

List of Illustrations

List of Illustrations

List of Illustrations

Artistic America,
Tiffany Glass,
and
Art Nouveau

Introduction

Samuel Bing (1838–1905) was a key figure in the evolution of those principles that have dominated the art world in the twentieth century. As a Parisian art dealer and promoter at the turn of the century, he was in close contact with many painters, sculptors, and architects who are now recognized as the pioneers of modern art. His *Salon de l'Art Nouveau* not only gave the name but was pivotal to the movement that generated an international style. His pavilion, *Art Nouveau Bing*, was one of the most effective displays at the Paris Exposition of 1900.[1] By the time of his death his contributions were familiar to artists and critics from Vienna to San Francisco. In an article published in *The Craftsman* in October 1903, he characterized himself as "the one who, eight years since, had the good fortune of aiding the latent aspirations of the period to assume a visible existence, and as serving as a sponsor to the new life."[2]

Bing first came to the attention of the art world at the Paris Exposition of 1878 where he exhibited his collection of Oriental decorative arts, including a large variety of Japanese ceramics.[3] Born in Hamburg, he had been employed in a German ceramic factory and came to Paris before 1871 where he became a naturalized French citizen. In 1875 he traveled to Japan and subse-

[1] Robert Koch, "Art Nouveau Bing," *Gazette des Beaux-Arts* (March 1959), pp. 179–190.

[2] S. Bing, "L'Art Nouveau," *The Craftsman*, Volume 5, No. 1 (October 1903), p. 1.

[3] Bing invariably used only his first initial. Gertrude Bing, who until recently worked at the Warburg Institute in London, insisted that he was her uncle and his name was Sigfried. However, her story does not check out with other sources, including *La Légion d'Honneur*, bestowed on Samuel Bing on July 12, 1890. Also see Gabriel P. Weisberg, "Samuel Bing: patron of art nouveau," *Connoisseur* (October 1969), pp. 119–125.

1

quently opened two shops in Paris as a dealer and importer of Japanese art. Vincent Van Gogh was one of his more illustrious clients.

Bing's first venture as a publisher was in 1888 when he launched *Artistic Japan,* a publication that appeared in three languages and ran thirty-six issues on a monthly basis until 1891. Besides several articles by Bing, other contributors include Philippe Burty, Roger Marx, and Edmond de Goncourt. In 1890 Bing organized a show of Japanese prints at the Ecole des Beaux-Arts and soon thereafter set off on a trip to visit the United States. The exact dates of his visit are not known except that they were between 1891 and 1894. In his writings he does not mention having visited the Chicago Columbian Exposition of 1893 although it is clear that he did include the Windy City on his tour. It is probable that Bing came to the United States in 1892 but did not complete the writing of his book on American art until 1895. The publication of the book coincides with the opening of his *Salon de l'Art Nouveau.* He was a modest man who liked to keep his private life in obscurity. No photographs of him have come to light, and there is even still some doubt about his first name.[4] One contemporary reference to his personality is by Roger Marx in *Artistic Japan* who refers to "its erudite editor, whose supreme ability and energetic enthusiasm are borne witness to in . . . the accomplishment of a precise programme."[5]

[4] Paul Gasnault, "La Céramique de l'Extrème Orient," *Gazette des Beaux-Arts,* Volume 18, Part 2 (1878), p. 910.
[5] Roger Marx, "On the role and influence of the arts of the Far East and of Japan," *Artistic Japan,* Volume 6, No. 36 (1891), p. 459.

When Bing set sail for New York City he was well prepared. In 1888 his firm had opened a showroom at 220 Fifth Avenue where his American representative, John Getz, conducted auction sales of Oriental objects. It is also likely that Bing was already acquainted with the four important collectors of Oriental art that receive special mention in his text. These were his American contemporaries:

Edward C. Moore (1827–1891) was a silversmith who had a major collection of ancient and Islamic art-effects. He originally learned his trade from his father, John Moore, who, until his retirement in 1851, worked exculsively for Marquand and Company. Edward C. Moore then took over the shop which, in 1868, was absorbed by Tiffany & Co., Moore becoming director of that firm. His designs for silver won him a gold medal in Paris in 1878 and he was decorated with the Legion of Honor in 1889. He was the one who first referred to his designs for silver as ''Saracenic.'' When, after his death in 1891, his collection was given to The Metropolitan Museum of Art, it included Greek, Roman, and Etruscan vases, Tanagra groups and figurines, and a variety of glass, jewelry, and metalwork.

Louis C. Tiffany (1848–1933) was the son of the founder of Tiffany & Co. who, before 1880, assembled a collection of Japanese arms and armor. Although he was Bing's junior by ten years, they did become good friends and business associates. Tiffany began his career as a painter, a pupil of George Inness, and in 1878, encouraged by Edward C. Moore, began to devote himself to modern decorative arts and interior decoration. Tiffany's crea-

tions in glass were featured at the opening exhibition of Bing's *Salon de l'Art Nouveau* in 1895.[6]

Samuel Colman (1832–1920) was a landscape painter who became a friend of Louis C. Tiffany. He collected Chinese porcelains and textiles and collaborated as Tiffany's associate from 1878 until 1890. After that he spent most of his time in Newport, Rhode Island, where he devoted himself exclusively to his painting.

John La Farge (1835–1910) was Tiffany's main competitor in glass and interiors. Although he was not a true collector, he had in 1886 traveled to the South Pacific where he had acquired some very fine textiles. He met Colman in the studio of the painter William M. Hunt and worked on the same project with Tiffany in New York in 1879, but they never collaborated. When La Farge met Bing in New York, he presented him with a lengthy document on how he (La Farge) had conceived the idea for the use of opalescent glass in windows. This was only partially included in Bing's book, as Tiffany also claimed to have been first in this development.[7]

Aside from the personalities involved, it is Bing's characterization of American art that makes his book a most remarkable document. Bing was an art historian who was not afraid to speculate about the cultural tendencies of his own time and, more than that, he was determined to do something to influence them. He was a keen observer, aware of the past and conscious of America's po-

[6] For his later accomplishments, see Robert Koch, *Louis C. Tiffany, Rebel in Glass*, Crown Publishers, New York, second edition, 1966.

[7] Cecilia Waern, *John La Farge, Artist and Writer*, London, 1896, p. 50.

tential greatness. He put his finger on those qualities that have brought this country to a position of world leadership; a "constant yearning for perfection" and a "desire to reach the top." His report is divided into four sections: painting, sculpture, architecture, and the industrial arts. He singles out, in each area, those works that he considers the most significant. He shows how the spirit of America is revealed in its art. In painting he reserves his highest praise for Winslow Homer, "an artist of considerable gifts and real inspiration," and James McNeill Whistler, whose "powerful conception of art . . . can belong only to a great artist." In sculpture he finds the most important contribution as "the translations of the natural forms of plant and animal life into ornamental language."

American architecture in the 'nineties was split into two hostile camps; those who strove to preserve the classic vernacular of Western European tradition and those who wished to create a new and original language of forms. Bing takes his stand with the latter. He refers to Henry H. Richardson as "a passionate spirit [who] felt the foment of that creative brilliance destined to propagate the gospel of a revolutionary art." His descriptions of the buildings he visited are a masterpiece of architectural criticism and his conclusions are as valid today as they were in 1895. His standards are clearly based on the subordination of form to function.

On the subject of the industrial arts, Bing is most passionate. As a man dedicated to the elevation of these arts to be considered on a par with the fine arts, he is enraptured by what he found in

the United States. He is particularly taken with the collective spirit in the workshops of those who apply art to useful objects, which he sees as a reflection of American democracy. Here he brings out the contributions of Moore, Tiffany, Colman, and La Farge. The lesson that he learned was that "The machine can propagate beautiful designs intelligently thought out and logically conditioned to facilitate multiplication. It will become an important factor in raising the level of public taste. Through the machine, a unique concept can, when sufficiently inspired, popularize to infinity the joy of pure form. . . ." Bing reaffirmed his conclusions eight years later when he wrote, "I express the conviction that America, more than any other country in the world, is the soil predestined to the most brilliant bloom of a future art which shall be vigorous and prolific."[8]

After visiting New York, Boston, Albany, Chicago, Cincinnati, Pittsburgh, and Washington, D.C., he returned home. Besides his notes, he also had a contract which gave him exclusive rights for the distribution of Tiffany glass in Europe and the British Isles. On June 2, 1894, he sold the first Tiffany vase to the Musée des Arts Décoratifs of the Louvre. In 1895 he exhibited, at the *Salon de Champ-de-Mars*, ten windows designed by French artists executed by Tiffany. The list includes Bonnard, Grasset, Ibels, Ranson, Roussel, Serusier, Toulouse-Lautrec, Vallotton, and Vuillard. These same windows were included in the exhibition when, on December 26, 1895, Bing opened his own *Salon de l'Art Nouveau*. In addition there were also twenty Tiffany

[8] S. Bing, "L'Art Nouveau," p. 14; p. 248 this volume.

vases and a wide variety of paintings, sculpture, and decorative arts from many countries.

The preface of Bing's book on American art is dated November 1895, and it was published from 22 Rue de Province, the address of the newly refurnished showrooms. It was hastily printed on poor paper without illustrations. It must be assumed that it got lost in the shuffle of the grand opening and that Bing was more anxious to put into operation the principles he had learned than to see his name in print.[9] He soon set about finding sympathetic designers to organize a new workshop based on the American prototype. He retained three artists, Georges de Feure, Edward Colonna, and Eugène Gaillard, and his son, Marcel Bing. Colonna had worked with Louis C. Tiffany in the early 'eighties. They made a big hit at the Paris Exposition in 1900,[10] and the name, Art Nouveau, has been identified with the movement ever since.

Bing was not alone in his enthusiastic appraisal of that which was then the most significant aspect of American art. A French painter and goldsmith, André Bouilhet, visited the Chicago Fair in 1893, and his report was published in the *Revue des arts décoratifs* the same year.[11] He refers to American silver flatware as a "style nouveau," inspired from India and named "Saracenic"

[9] A condensed version of the chapters on American architecture and industrial art was prepared by the author and published as S. Bing, "L'architecture et les arts décoratifs en Amérique," *Revue Encyclopédique Larousse*, Volume 7, No. 223 (December 1897), pp. 1029–1036.

[10] Gabriel Mourey, "Round the Exhibition—The House of the 'Art Nouveau Bing,'" *The Studio*, Volume 20, No. 43 (1900), pp. 164–181.

[11] André Bouilhet, "L'Exposition de Chicago, notes de voyage d'un orfèvre," *Revue des arts décoratifs*, Volume 14 (1893), pp. 65–79.

by its creator, Mr. Moore, an art director of Tiffany & Co. For the highest praise he singles out the work of Louis Sullivan and Louis C. Tiffany. He considered Sullivan's Transportation Building the best of the Fair and includes descriptions and illustrations of the Auditorium and the Getty Tomb that were not part of the Exposition. He rated Tiffany's Chapel of 1893 as second-best, "somewhat theatrical but a great success."

Another visitor, who came from England, was Cecilia Waern. After completing a biography of John La Farge, she wrote an article in praise of Tiffany glass that appeared in *The Studio* in 1897 and 1898. [12] But Bing, who was sole distributor of Tiffany's wares in Europe, felt he had to do even more. He wrote an article for the first volume of the German periodical, *Kunst und Kunsthandwerk* in 1898 which, translated into English, served as introduction to a catalogue of an exhibition of L'Art Nouveau at the Grafton Galleries in London in 1899. [13] It is the most eloquent firsthand interpretation of Tiffany's production in the 'nineties and is therefore included here.

After the success of Art Nouveau Bing in Paris at the 1900 Exposition, *The Architectural Record* requested of Bing a brief definition of his concept of the new art. Published in 1902, it is also included.

On only one other occasion Bing felt the need to take to the

[12] Cecilia Waern, "The Industrial Arts of America: The Tiffany Glass and Decorating Company," *The Studio*, Volume 11, No. 7 (1897), pp. 156–165, and Volume 14, No. 63 (1898), pp. 16–21.
[13] Horace Townsend, "American and French Applied Art at the Grafton Galleries," *The Studio*, Volume 17, No. 75 (1899), pp. 39–46.

pen to defend this point of view. In December 1902 Professor A. D. F. Hamlin of Columbia University published an article, "L'Art Nouveau, Its Origin and Development," which appeared in *The Craftsman.* He characterized the new art as "chiefly a negative movement: a movement away from a fixed point, not toward one." After a lengthy discussion of contemporary artists, with no mention of either Tiffany or Bing, Hamlin described Hector Guimard's Castel Béranger as "a jumble of incoherent motives without grace or harmony" and concludes, "If this is the mature fruit in architecture of the Art Nouveau, heaven defend our country from the sowing of that seed here!"[14] Bing's reply, published in the same periodical less than a year later, is also included in this volume.

The controversy, with traditionalism on one side and creative originality on the other, continues to the present day. It is our conviction that by reprinting these published writings of Samuel Bing, they will shed new light on the origin and the nature of modern art.

Robert Koch
June 1969

[14] A. D. F. Hamlin, "L'Art Nouveau: Its Origin and Development." *The Craftsman,* Volume 3, No. 3 (1902), p. 142.

To M. Henri Roujon
Directeur des Beaux-Arts

M. le Directeur:

Upon my departure for the United States you asked me to return with a report on the development of art in America and its possibilities for the future.

This subject—by its novelty alone—would indeed merit a more erudite explorer, just as its complexity would really require a study of two or three volumes.

The following pages, brief notes of a tourist particularly interested in art, will perhaps suffice to indicate the unusual achievements of an enthusiastic people, whose vibrant youth is nurtured by the tangled remains of ages past.

S. Bing
Paris, November 1895.

The translator gratefully acknowledges the erudition and goodwill of Mr. William R. Johnston, Assistant Director, The Walters Art Gallery; Mrs. Dora Jane Janson; Professor Peter H. Von Blanckenhagen, and Colin Eisler, whose advice, concerning both style and content, heeded and unheeded, is ever appreciated.

I
Artistic America
(La Culture artistique en Amérique, 1895)
by S. Bing
translated by Benita Eisler

Introduction

Since the time, not so very long ago, when a number of self-contained colonies were founded on the eastern seaboard of the new continent, many different visitors have recounted their impressions of the New World. For a long while, however, there were no specific observations concerning the intellectual life of the American people. Nor did the hectic travels of businessmen or aimless swarms of tourists bring back anything to enlighten us in this area. Only very recently, have a few travelers, both more inquiring and cultivated than their predecessors, provided us with illuminating accounts, invaluable documents revealing the moral and intellectual characteristics of the major classes of American society. No land could have been painted in more brilliant colors than this same America as seen by a succession of perceptive observers at the very moment of their visit.

But such accounts raise the question as to whether any inquiry, strictly limited to reportage, is not somewhat unbalanced by its exclusive focus on the transient contemporary scene.

To form any sound judgment of transatlantic phenomena, they should be viewed as so many elements of a world in the process of formation, as transitory elements, in which certain vestiges of the past reveal new seeds in germination. We can never overestimate the prodigious forces of change at work in the United States, relentlessly carrying out their colossal task.

In first landing on new soil, our mind still imbued with the familiar, we may not realize that in a strange milieu, where every-

thing foments without respite, things are at times akin to those stars still perceived by the human eye, which in fact may no longer exist. Thus, phenomena we assume to be present, may be only a reflection of the past. For the American, however, *yesterday* no longer counts while *today* exists merely as preparation for *tomorrow.* [1]

The entire past of American culture is thus comprised of a series of spurts forward. One day the desire mounts to break away from the banality of everyday life. But instead of progressing gradually, in accordance with general laws, the thrusts follow one another, at broken intervals, attempting to move, without transition, from the most rudimentary mores to the most extreme refinements. Aspirations go astray through inexperience, ending in the

[1] When a foreigner, landing in New York, first visits Fifth Avenue, the main thoroughfare, flanked by splendid mansions, he is astounded to observe, from time to time, a modest little omnibus, slowly pulled by a sad old horse, within which seven or eight passengers are uncomfortably seated, squeezed one against the other. There is not even a conductor posted in back. To secure a seat, the passenger drops his pennies in a changebox placed behind the driver's seat. No other means of public transportation exists on this splendid avenue of luxurious houses. No doubt the residents saw to it that their aristocratic serenity should remain undisturbed. But suddenly nearby, without transition, to the left and right, and especially along the great parallel thoroughfares, we see busy crisscrossings of the most modern vehicles: trolleys, trams, steam and electric trains, each of them the most advanced model of its kind, embodying the highest achievements of modern ingenuity as applied to comfort and rapid transportation. These two contrasting elements, existing side by side all the year round, may stand as a parable which illustrates American life more vividly than could a dozen pages. The little Fifth Avenue omnibus symbolizes those old-fashioned elements which have not yet vanished—and whose existence may easily confuse the visitor as to the country's progress. These are the strange survivors of some persistent larvae, awaiting their sudden metamorphosis. From one day to the next, without passing through any series of intermediary phases, defying all the laws of gradual progress, the old, outdated bus will give way to some new, as yet unknown system, which, in its dazzling perfection, will make everything invented before that moment obsolete.

false glitter of intemperate luxury. This efflorescence has taken place in such a hasty and impetuous way that some observers have compared its results to the products of an overheated greenhouse— an apt comparison in many cases. But one very important point is thus missed: the rich exuberance of forced flowers has hidden the unobtrusive growth of a few young shoots breaking through the earth with fresh charm, which promise, when they bloom, the evolution of a new strain.

Is this a sign of sudden metamorphosis of the arts in America? Will this nation now produce a pure and harmonious art? Alas, the creative spirit, already rare in those surroundings wrought by ancient civilizations, must remain still more so in this vast, barely cleared land. But however timidly America may take the first step in a new direction, we can safely predict that the last steps will always lead to some result or solution of supreme brilliance. Many resources that seem to be missing within this vigorous organism simply lie dormant. But as soon as the prospect of unforeseen conquest seizes the best minds, the creative surge cannot be restrained. Impelled by instinctive impulse, by an imperious moral duty, this people pushes every undertaking considered worthwhile to its ultimate conclusion. Even when they find themselves on the wrong track, Americans persevere with undiminished ardor, until such time as their eyes are opened once and for all to the truth. This constant yearning for perfection is the source of America's greatness, while, at the same time, the desire to reach the top lies at the root of much of the frenzy which shocks foreign observers; thus, the ruthless pursuit of unlimited wealth and, above all, the

absence of any sense of proportion in the glittering display of luxury among the rich.[2]

But this same power which, under certain circumstances, results in evil, is, nonetheless, ever present, in all its energy, to act no less efficiently as a force for good. And if, at this very moment, shining examples herald the birth of a new era; if simple beauty, the taste for subdued charm has already begun to convert the élite, then we may be certain that America will devote to the solution of aesthetic problems the same stubborn energy that led to such unfortunate extravagance in the past. Assuredly, her way will be less easy in the realm of the abstract, than it has been in the material ordering of things, in her impressive social and political achievements, for example, or in the scientific domain. Above all, progress will be less accelerated when it comes to independent creativity, freed from the past. But conversely, each step forward, each bold stride will then assume staggering proportions, transcending the limits of present-day knowledge. It may not even suffice to consider each advance as one more link in the centuries-old chain of art. Each stride may well prove a new point of departure. If Americans today seek the formula to incarnate their special sensibility, may it not profit us, travelers weary from a long

[2] We would be wrong in ascribing this unquenchable thirst for wealth to savage cupidity alone. In the eyes of most Americans, money is simply the most powerful instrument in the creation of greatness, for the glory of the country, the native city, as an example to posterity. When some great enterprise is proposed, millions of dollars appear as though by magic, taking flight to work toward the realization of the grandiose scheme. And whether this inspired undertaking be public or private—a new university, a foundation of some sort to aid adult education, or a museum of art—private enterprise unfailingly responds in unprecedented fashion, so that all contribute to the highest possible degree of perfection.

journey, burdened by too much knowledge, to emulate their surges of vitality? Who knows but that the bold inexperience of this youthful country may not lead our ancient wisdom toward a second spring—to open unknown paths before our measured steps which dare no longer wander outside our ancestral confines?

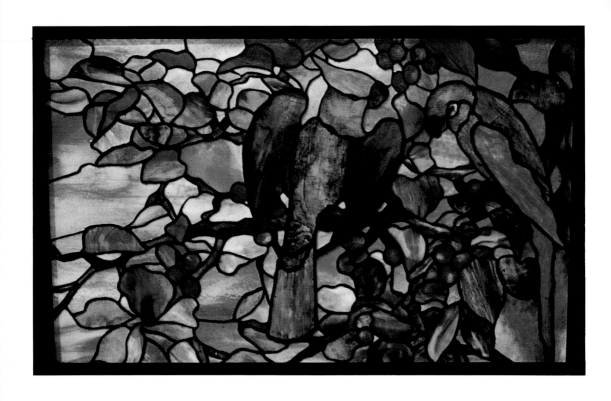

Louis C. Tiffany, *Parrot* Window for the Library
Added to the Watts-Sherman
House, Newport, Rhode Island,
by Stanford White, ca. 1880.
Robert Koch Photo,
Courtesy of Hugh F. McKean.

Painting

After the efforts of a century to accommodate the elements of public prosperity and the power of private fortunes, the American people, their nation solidly established, decided the moment had come for her adornment. But to whom could they turn? Within this populous nation of immigrants, intellectually adventurous but unschooled in Beauty, there could be no possibility for the genesis of a national art. Since America's aspirations were still too vague and diffuse to support an indigenous movement, art seemed inconceivable without recourse to Europe, long the provider of so many objects for everyday use.

But, by strange contrast, at just the time when this country was still unskilled in the industrial arts, initiative was already apparent in the fine arts, painting in particular.

From her earliest beginnings as a nation, included by fate among the masses who landed upon those distant shores, were a few gifted immigrants, who, delighted by the bracing air of an open frontier, settled there to raise their families. Thus, it should not surprise us to find in some of their descendants the atavistic stirrings of an artistic vocation. But despite the persistent effort to emerge as a new race, their European heritage was still too strong for the pioneers of American art to produce anything other than a more or less unconscious continuation of their ancestral tradition.

In every branch of practical endeavor, the young nation succeeded in breaking her European ties, but as soon as art came into

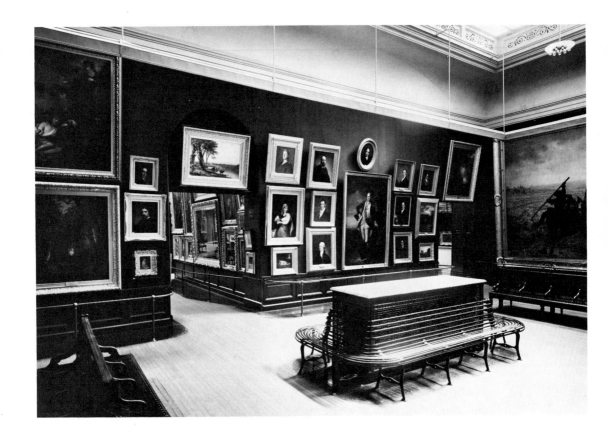

1. The Metropolitan Museum of Art, Gallery 13,
American Wing, in 1899.
Courtesy of The Metropolitan Museum of Art.

play, she remained bereft, without the youthful simplicity of an emerging civilization or the precious heritage of artistic tradition. The American situation was a uniquely hybrid one, totally without parallel. Thus we find the paradox of a country, wanting only to succeed on her own, eager to renounce all traditional influences, yet forced by circumstance to depend upon her countries of origin for fertilization, and leaving it to succeeding generations to revive these borrowed strains with fresh young blood.

By the seventeenth century, several artists were already active. in *Memorial Hall,* Harvard University, we can still see a number of portraits, the oldest of which bear dates from 1670–1680. The rigidity of their execution and the inert expression on the faces in these anonymous works reveal them as the manifestations of an as yet inexperienced art. We might mention, in passing, the names of *Watson, Smibert, Blackburn,* and *Williams,* all of whom came to America at the beginning of the eighteenth century, and whose rather undistinguished paintings may be seen in the museums of Boston, Philadelphia, and Yale College (New Haven), before we come to the first name to be found in the ranks of indigenous artists, *Robert Feke.*

Like nearly all early American painters, Feke, active in Philadelphia around 1750, limited himself to portraiture. Some of his paintings, notably those in Newport, Providence (Rhode Island), and Brunswick (Maine), show great technical skill and sensitive observation of physiognomy.

The work of two near contemporaries of Feke, *Matthew Pratt*

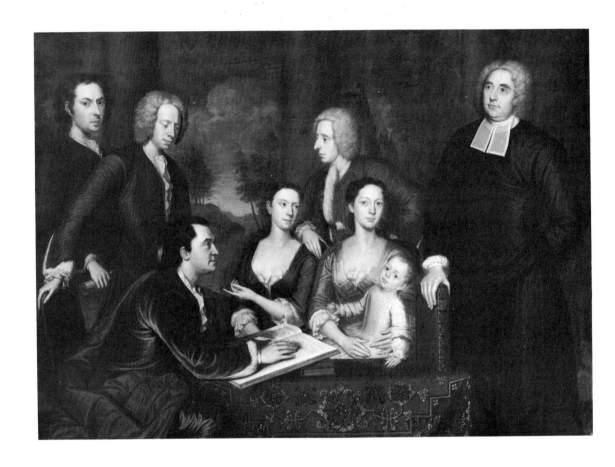

2. John Smibert, *The Bermuda Group, Bishop George
Berkeley and His Family*, 1729.
Courtesy of Yale University Art Gallery,
gift of Isaac Lothrop, 1808.

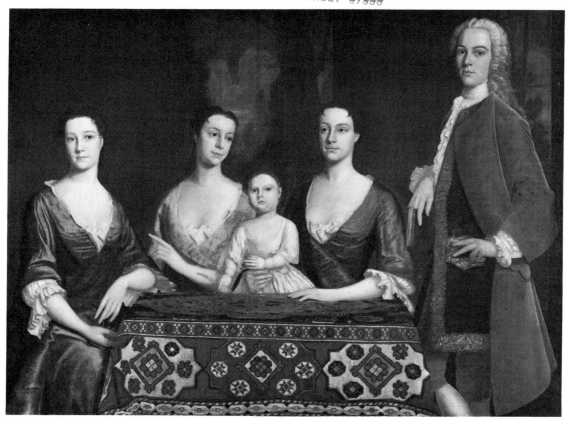

21

and *Henry Bembridge,* is of little intrinsic interest, other than the fact that *Bembridge* was one of the first American painters to visit Europe, where he studied with Batoni and Raphaël Mengs. Neither Germany, nor Italy, however, was to exert any significant influence upon the future art of the New World. This role was, for a long time, pre-empted by England. From their earliest beginnings, American primitives were reminiscent of English painting. But these same influences, always latent, were to take root and manifest themselves in decisive fashion. At just the time when the elegance and nobility of Reynolds and Gainsborough were the glory of English art, two talented painters, *West* and *Copley,* arrived in London. Far from being considered novices come to complete their training, they were welcomed as masters. And their growing fame in that city soon attracted other American painters, avid to learn in this artistic center, under the friendly aegis of their successful compatriots.

Benjamin West (1738–1820), born in Springfield, Pennsylvania, was known in Philadelphia and New York as a skilled portraitist from the age of eighteen. But, upon arriving in London in 1763, after a three-year stay in Rome, he was greeted with such acclaim that he never returned to America. Was this due to the prestige of history painting as practiced by West, unusual in the midst of the pleasant intimacy of contemporary art? Whatever the case, honors and wealth were heaped upon him, and for thirty years he remained the favorite painter of the king until, with the death of Reynolds, he was named president of the Royal Academy.

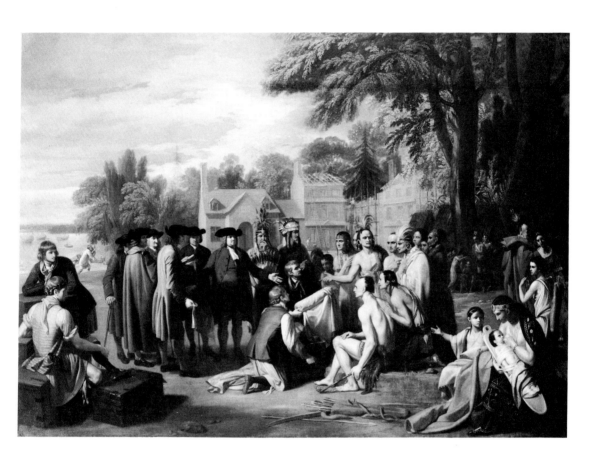

23

John S. Copley (1737–1815) a native of Boston, followed closely in the wake of West's brilliant success. Arriving in London in 1774, his talent, without arousing quite the enthusiasm accorded his predecessor, was nonetheless highly praised and led to his reception as a member of the Royal Academy. It would be unjust to deny to Copley's art the presence of a certain sense of movement, a vivid gift for the dramatic exceptional indeed for the time, which characterize his depiction of modern history. But when we compare his paintings with those English masterpieces now surrounding them at the National Gallery, it is difficult to explain why his painting, and still less those of the academic West, should have so delighted England, especially in that brilliant period which saw the flowering of her own fresh and exuberant art. Whatever the reason, the art of West and Copley once again affirmed the fact that not one atom of youthful American verve had as yet appeared in her painting, which remained at the exact point at which sudden transplantation into alien soil had immobilized it in the sixteenth century.

The transatlantic repercussion of West and Copley's brilliant success encouraged a still greater taste for the classical tradition. Happily, America was at this time marching toward that major event of its history, which, leading to the brilliant triumph of its independence, would by the same token, open the way for independent art, this time reflecting national life at its most turbulent. The explosion of the War of Independence, in art, as in politics, spelled the end of the first phase of American history, known as the Colonial Period.

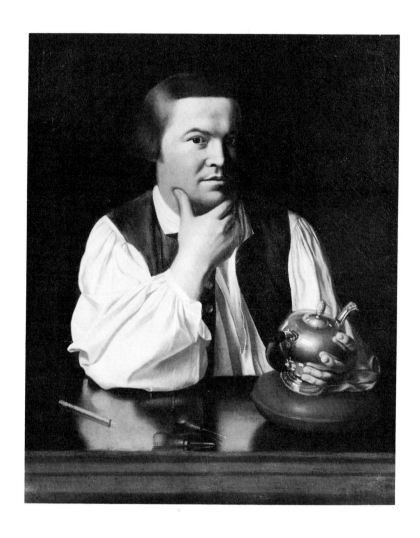

The following stage, the Revolutionary Period, produced the two best artists of the last century: Stuart and Trumbull, whose vivid, colorful strokes immortalized the principal figures and famous episodes of those heroic times. *Gilbert Stuart* (1756–1828) born in Narragansett (Rhode Island) was the indefatigable portraitist of all the famous patriots of his period. His innumerable likenesses of General Washington and their copies haunt the visitor to every public gallery. Stuart's work moreover, is of very uneven quality and would suggest that he was badly in need of money at several points in his career. Some of his paintings, however, are certainly the equal of many fine English portraits. Stuart was among the artists who had worked in West's studio. A number of his paintings remained in England, and at the time of the loan exhibition of his work organized in 1878 at the Royal Academy one of his major paintings was still attributed to Gainsborough.

John Trumbull (1756–1843), another excellent portraitist, owes his greatest claim to fame to a very different facet of his talent. As one of Washington's officers, he witnessed several memorable battles and other famous scenes of his country's history, all stimulating his imagination. Fifty-four of his paintings now belong to Yale College in New Haven, while the Boston Museum owns several important pictures as well. The vast decorative paintings for the Capitol in Washington were the product of his old age and are totally undistinguished. Trumbull's fame crossed the Atlantic, and it is said that Goethe, while admiring one of his battle scenes, nonetheless criticized certain minor de-

6. Gilbert Stuart, *George Washington*, ca. 1796.
Courtesy of The Metropolitan Museum of Art,
gift of H. O. Havemeyer, 1888.

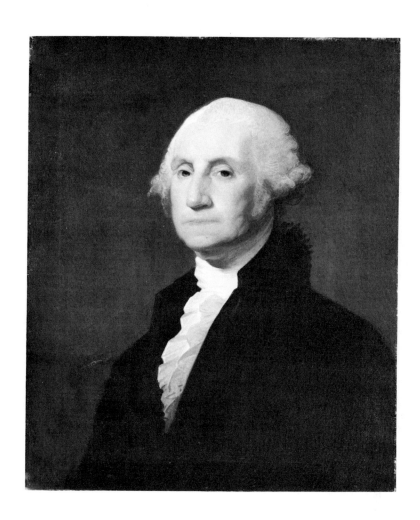

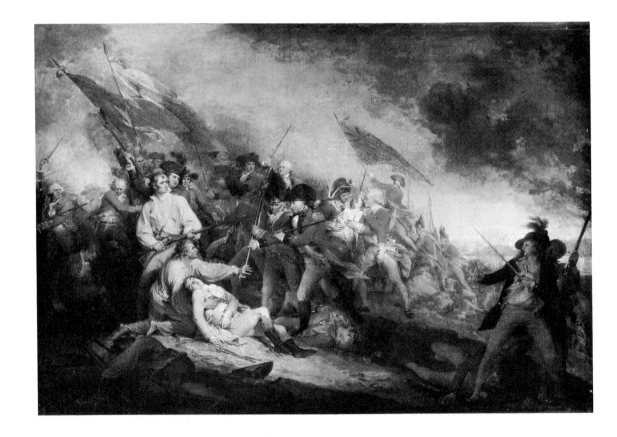

7. John Trumbull, *Battle of Bunker's Hill*, 1786.
Courtesy of the Yale University Art Gallery.

tails of color and proportion, finding, for example, the heads too small for the bodies.

The example of Stuart and Trumbull was to remain without issue, and the study of their own environment interested few artists. American art was still too obsessed by the prestige of classicism, or else, too attracted by contemporary England, to the point where Americans felt that the summits of art could not be scaled without first visiting ancient Rome or contemporary London.

A third phase, marked by tentative exploration, followed the Revolutionary Period. This period may also be characterized as one marking the rise to fame—as rapid as it was undeserved—of *Washington Allston* (1779–1813), the foremost representative of that ultra-academic painting which thrives on harping on every subject taken from mythology or biblical history. Of the same period and school was *John Vanderlyn* (1776–1820), who was awarded a medal at the Paris Salon for his *Marius on the Ruins of Carthage.* Still other artists deserve mention for quite different aspects of their life or character. In *Samuel F. B. Morse* we find one of those astoundingly complex minds in which America seems to specialize. An interesting painter in his strange boldness of color and line, the portraitist of Lafayette among others, Morse became, in his later years, a brilliant electrical engineer and inventor of the famed telegraph system that bears his name. *Robert Leslie* (1794–1859) is a name familiar to us as a popular English painter. Born in London, of American parents, he returned with them to America when he was five years of age. A large part of

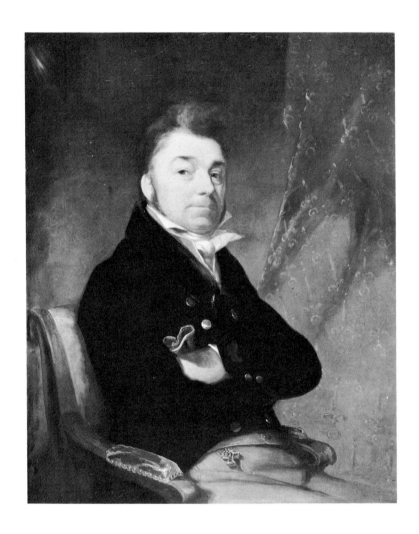

8. Samuel F. B. Morse, *David C. DeForest*, ca. 1820.
Courtesy of the Yale University Art Gallery,
gift of Mrs. P. J. Griffin, 1893.

his later life, however, was spent in England, where he painted most of his genre paintings, more noted for painstaking rendering of anecdote than for any serious artistic quality. His American works may be seen in New York (Lenox Gallery) and in Philadelphia (Academy of Art).

In contrast to Leslie who, although American in origin, drew his inspiration from English life, (*William*) *Sidney Mount* (1807–1868) must be considered the first purely American genre painter. With an equal abundance of verve and banality, Mount depicted all the local customs of the New World, and his compositions, destined primarily for the delectation of the mass market, were reproduced in infinite numbers of engravings.

At the same time, in opposition to this low level of genre painting, heroic subject matter found, for the first time since Trumbull, a zealous interpreter in *Emmanuel Leutze* (1816–1868). Curiously enough, in spite of the American character of his subject matter, which often evoked military scenes of the recent past, Leutze, an artist of German origin, became a great disciple of the Düsseldorf School. By disseminating new principles of art which then mingled with the multitude of doctrines in vogue, Leutze served to enrich the existing confusion. Thus, still another alien element was added to the crucible from which a native art had just begun to emerge. Now almost all European schools had their American spokesmen. But it was French art which served as model for the major practitioner of American landscape painting, *Thomas Cole* (1801–1848). He drew inspiration from Claude Lorrain and Poussin, while the portraitists, among whom *Henry*

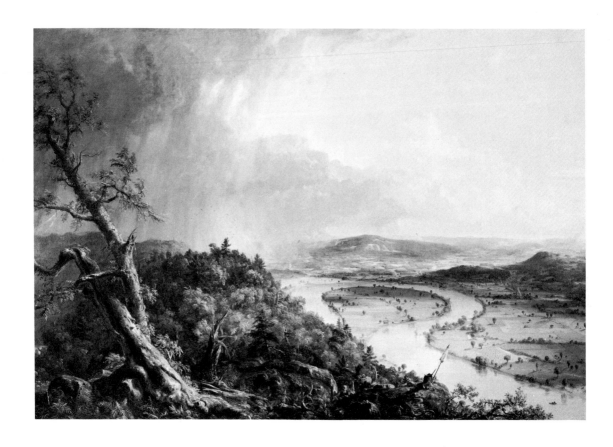

9. Thomas Cole, *The Oxbow*, 1846.
Courtesy of The Metropolitan Museum of Art,
gift of Mrs. Russell Sage, 1908.

Inman (1801–1846) was the most gifted of the period, remained faithful to their English sources.

A few rebellious artists took issue with this submission to foreign formulas, objecting especially to their irrelevance. In 1825, a National Academy was established in New York to battle against the effects of this tutelage. As may be imagined, such a program is easier to propose than to execute, especially as those names heading the membership list of the new institution—Cole, Inman, Vanderlyn—were hardly synonymous with bold new concepts in art.

But the principle had been stated, and with succeeding generations, results were to become apparent, if not in every branch of painting, then at least in one: the landscape. A fervent group of young artists turned toward the picturesque aspect of the neighboring countryside. From this group, somewhat jokingly christened the Hudson River School, emerged artists of serious talent, among whom should be mentioned *John F. Kensett* (1818–1872) and *Sanford R. Gifford* (1823–1880). Their contemporaries included an equally gifted painter of seascapes (which strangely enough, until this time had been lacking in this maritime nation), *James Hamilton* (1819–1878), who, under the influence of Turner, displayed his own splendid coloristic harmonies and picturesque composition.

When, at last, a new movement began to take shape, characterized by a straightforward, individual viewpoint, which would

10. John Frederick Kensett, *Long Island Sound from Fish Island*, ca. 1870. Courtesy of The Metropolitan Museum of Art, gift of Thomas Kensett, 1874.

certainly have led to the formulation of a new American style, it was deflected by the rebirth of French art. The work of Delacroix and his followers, as well as that of an innovational school of French landscape painters whose leaders were Rousseau, Diaz, Dupré, Troyon, Corot, Millet, and Daubigny, distracted the brave efforts of young American artists.

Were these constellations seen as a sign by American painters that the moment was ill-chosen to concentrate on their own experiments, when, in fact, so many helping hands seemed to beckon from abroad? Whatever the reason, the new French art served as the signal for a mass exodus. No doubt, even as they made their way to Paris and Barbizon studios, American artists still hoped to retain their natural instincts, imagining they would remain firmly rooted, merely to be enriched by newly acquired skill and knowledge.

To their grief, most Americans were mistaken. By abandoning themselves to another's lead, by renouncing at a critical moment the persistent quest for their own manner of feeling and expression, Americans would, for many years to come, be relegated to a peripheral role in the great arena of world art.

After these three successive stages:
The Colonial Period (prior to 1775)—entirely subject to English influence (West and Copley);
The Revolutionary Period (1775–1800)—marked by the advent of patriotic art (Stuart and Trumbull);
The Experimental Period (1800–1840)—an echo of all previous

schools, but a period which saw, toward the end, some signs of independence (Cole, Inman, Kensett, and Gifford);

The Contemporary Period begins, one devoted almost exclusively to modern French art. A few rare dissidents found their ideal in German art, notably Munich, but these were exceptions.

The detailed history of these diverse stages unfolds in every public gallery in the cities of New York, Boston, Philadelphia, etc. But if, within these museums, one is constantly struck by so much effort expended by an art without self-confidence, in need of external support, and finally, subject to French modern art— all of these things become far more explicable to anyone who has had the opportunity of meeting the painters themselves and who has heard them speak of their own experiences. All of these artists had made their youthful pilgrimage to France, breathing our artistic atmosphere, living our life, accommodating their personal vision to prevailing ideas, forming and reforming their feelings to accord with the eddies of each evolution. Upon return to native soil, their talent, nurtured by Europe, often seemed uprooted, repeating the identical form crystallized at the moment of departure. These artists continued to produce mechanically, but their thoughts, almost always turned toward Europe, could only find inspiration in the nostalgia of French memories.

But one change had, nonetheless, become apparent. Their earlier attachment to the routine—a flagrant anomaly in this spontaneous people—was broken. Every creative spirit was open to the clarity of new vistas.

Among the oldest of these artists to feel the attraction of French art was *William Morris Hunt* (1824–1879) whose painting, although generally lacking distinctive character, is so close at times to his French models that it is impossible to tell them apart. A curious exhibition organized by friends of the deceased painter, and held in a famous Boston club* (April 1894) presents, in this respect, an interesting study. Landscapes reminiscent of Millet were hung next to several female nudes and figure groups which might easily have been attributed to Couture. It should be added that these highly skilled pastiches were interspersed, happily, by more personal renderings, freely inspired by the American landscape. In this area, Hunt has left us some important studies of Niagara, striking for their powerful breadth and strong coloring.

Another Bostonian of the same period, *Richard H. Fuller* (1822–1871), is less skillful than Hunt, certainly, but far more spontaneous in style. In the course of his eccentric and typically American career (he was first a tobacconist, then a lamplighter), he became a completely self-taught artist. And although he never left his own country, he was adept at painting landscapes in the French manner, to which Fuller added his own personal touch. He should not be confused with another artist, *George Fuller* (1822–1884). A competent landscape painter, he was far better known than the Bostonian, although a much more slavish imitator of the French manner—a merit scarcely justifying his appellation as "the American Millet" by which his countrymen honored him.

* Editor's note: St. Botolph Club.

12. Richard Henry Fuller, *Near Chelsea*, 1867.
Courtesy of the Museum of Fine Arts, Boston,
gift of Martha B. Angell.

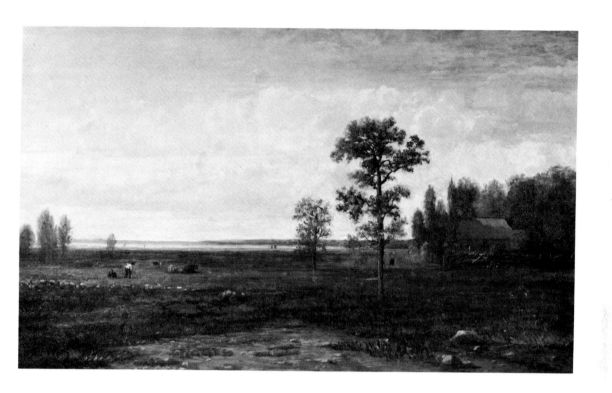

In the last forty years, the number of artists has grown so much that it would be impossible to mention them all in these brief notes. In their art, moreover, they display very real qualities, from the point of view of training, conscientiousness, and fine coloristic sense, but it is still an art of limited invention. From this majority, however, there have already emerged a few artists of more than average talents who, after a slow beginning, show an ever-increasing maturity.

More and more, American art grows stronger in landscape painting, and its most gifted interpreter was *George Inness*. With a deep feeling for nature, Inness incorporated his poetic vision within strikingly original forms. Follower of both Rousseau and Millet—less straightforward and wholesome than the latter but more of a synthesist than the former—his warm tones remind us of Gainsborough, while at other times his work recalls some of Constable's most luminous paintings. Inness, following the example of his chosen masters, never abandoned himself to classical landscape, whether conventional or symbolic. Instead, he faithfully rendered a particular site, ordinary or picturesque, of his own country, seeking to capture the feeling of intimacy, joyous or melancholy, emanating from nature, different at every hour of the day, varying with fleeting atmospheric conditions. Inness died at the age of sixty-eight (July 1894), his talent still full of youthful promise.

Inness will live on through his far-reaching influence as much as by his own highly personal work. An important group of young landscape painters are now following the trails which he

13. George Inness, *Sunrise*, 1887.
Courtesy of The Metropolitan Museum of Art,
anonymous gift in memory of Emil Thiele, 1954.

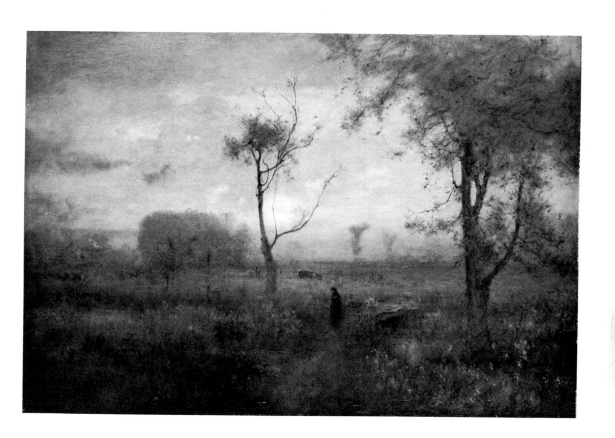

blazed. The artist who has come closest to Inness, and may yet go beyond him in the exquisite finesse of his coloring, the sober ordering of his composition, the tightly knit quality of his draughtsmanship is *Dwight W. Tryon*, a highly esteemed painter at this writing.

If American art had managed to define its character largely through landscape painting, there were still numerous artists working in other areas. Nor did the American passion for diversity extend to choice of subject matter alone. Nothing is more revelatory of the feverish thirst for discovery which obsessed American artists than the sudden leaps, the extraordinary abandon with which a given artist deserts his usual type of painting to try its antithesis. The observer is often astounded to find the same signature at the bottom of an impressionist sketch which he last saw affixed to a thoroughly academic study—such is the case with the well-known painter, *J. Alden Weir* (1852–1889). It would be difficult to foresee whether these unsettling habits will prove advantageous for the future of American art: for the moment, they seem to be more a source of weakness.

Unquestionably, the bleakest side of American art is shown in genre painting. The great number of painters engaged by this undistinguished art form can scarcely be said to have further enhanced it, either by their exceptional talent or inspired inventiveness. Confronted by the tiresome series of trivial anecdotes, our boredom increases as we see how crudely figures are outlined against the background color, instead of dissolving in living atmosphere, as in the work of the best American landscape paint-

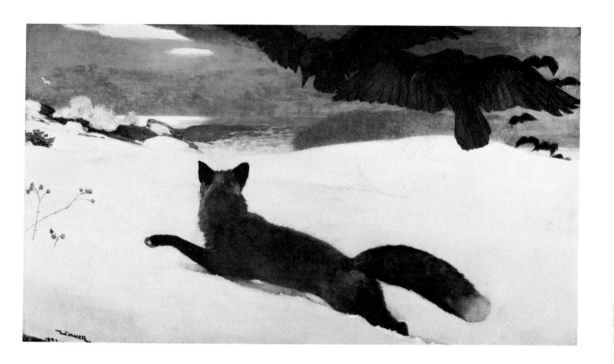

ers. It would be unfair, to be sure, to extend this criticism to all figure painters. There are happy exceptions here as well, who stand out in the midst of the prevailing mediocrity. Among the exceptions, is certainly *Winslow Homer*, an artist of considerable gifts and real inspiration. His highly individual compositions show particular skill in depicting the lively Negro people. Homer is also fond of evoking strange scenes which unfold in a fabulous world of his own imagining.

The few preceding examples should suffice to indicate the interaction of French influences upon American art which developed at home. Those artists who settled in France form a special group. More fortunate than their compatriots whose return to the United States arrested their talent, they retained, for the most part, the ardent creative temperament and sharp intelligence through which they held their own in the midst of general confusion. Their role is too well known to require further comment.[1]

Notwithstanding, there was sufficient talent among those who remained at home to merit the esteem of their contemporaries. In 1894 in a New York exhibition, *Alexander Harrison* tried to show the synthesis evolved from his persistent experimentation. His aim in these works was to reveal every nuance which a discerning eye could glean from apparently identical scenes. And he could have provided no more convincing proof than his studies of the diverse effects of moonlight upon silent sheets of water

[1] Among the most assiduous guests of our annual Salons, we should recall the names of Sargent, Dannat, Alexander, Melchers, Stewart, MacEwen Johnston, Walter Gay, Weeks, Pearce, Vail, and Abbey, an interesting draftsman living in England.

along a deserted beach, or the capricious dance of light, dappling the pearly skins of young women bathing under the trees.

Other artists seem still more detached from any concern for the country of their birth. The exquisitely gifted *Mary Cassatt* is rarely seen in her native land, which she never again plans to visit. Equally remote, however, from our own militant cliques, this painter, concentrating solely upon her personal vision, represents the essence of those whose spontaneous spirit fosters the hope that their youthful, vital country will one day reveal to the world an equally fresh, vigorous art. This hope grows still stronger when, after two long centuries of aborted talent, after so many timid advances, followed by long periods of regression, we are finally to witness the unfolding of that powerful conception of art which can belong only to a great artist, that of *James McNeill Whistler.*

As we contemplate his lofty, serenely confident art, which, although obviously subject to latent French influence (we should also note that everything has roots in precedent), we learn more than one lesson; the first is that no realm is too exalted for American genius to conquer—be it even the arduous domain of painting. Why should it be that so grueling a struggle was essential in the only art form, painting, whose beginnings could be traced to the America's earliest history?

The difficulty lies in the great length of time during which painting was practiced. The population had not yet merged into a sufficiently compact and autonomous mass to originate its own aesthetic ideal. In its beginnings, American painting consisted of

46

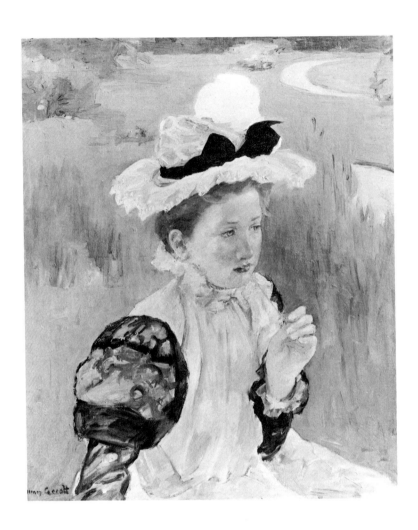

15. Mary Cassatt, *Portrait of a Young Girl*, 1899.
Courtesy of The Metropolitan Museum of Art,
anonymous gift, 1922.

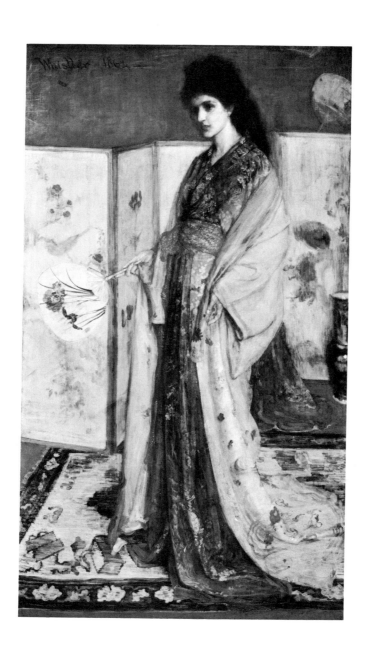

the remains of older art forms, born elsewhere. It followed long outdated laws, accepting them as immutable dogma to be transmitted to succeeding generations. And when finally, the winds of innovation and change came to nationalize art and to imbue it with new sensations, they came too late. Pedantic training, by crushing the very talent it should have formed, immutably fixed the direction of American art.

Nonetheless, the continuing spectacle of this brave nation's unconquerable energy, and the many irrefutable proofs of her perfectibility convince us that she is indeed capable of forging a new art, an art in her own image, reflecting her own conception of life, her own dreams of beauty, and finally, her own philosophy. This will be an extraordinary experiment to observe, to see whether a fraction of humanity can retrace its steps in accordance with the logical order of things, whether an art already possessed of the most sophisticated skills will also be able to recover the freshness of impression characteristic of primitive periods; it will be interesting to see how this intensely vital people—themselves the striking image of youthful vitality grafted upon age-old elements—will succeed, through the exercise of traditional techniques, in embodying a new ideal.

Sculpture

Faced with the most difficult of art forms, the sculptor's task is to animate rebellious matter, where, at each moment, the sublime teeters on the brink of the ridiculous. Before this lofty art, whose austere charms are unveiled to the trained eye, it is only natural that America, recently emerged from the wilderness, should, for so long a time have had neither the craftsmen skilled in sculpture's severe laws nor a public to do her honor.

Only at the beginning of the present century did the first group of American sculptors emerge, of whom *John Frazee* (1790–1852 was the oldest, and *Horatio Greenough,* his junior by fifteen years, the most skilled. Greenough created the equestrian figure of Washington erected in the city that bears his name. In the following generation, the most gifted was *Henry Brown,* if his talent is to be judged by the monuments in New York and Washington, D.C. These are the two American cities in particular whose parks and squares are filled with statues, where every famous general or statesman[1] in the history of this young country may be seen standing, seated, or astride. But if there is nothing wrong in sharing this enthusiastic cult for glorious heroes, it still may seem excessive to extend the same admiration to their numerous stone effigies, whose primary aim was undoubtedly that of letting the new art form try its strength.

[1] Few capitals enclose as numerous a marble population, in proportion to its living one, as does Washington, that elegant and empty city, with its vast avenues, certainly deserving of the nickname "the City of Magnificent Distances."

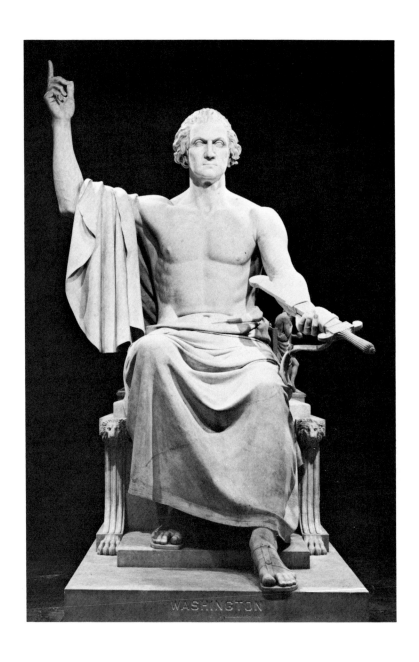

17. Horatio Greenough, *George Washington*, 1832–1841.
Courtesy of the Smithsonian Institution,
Washington, D.C.

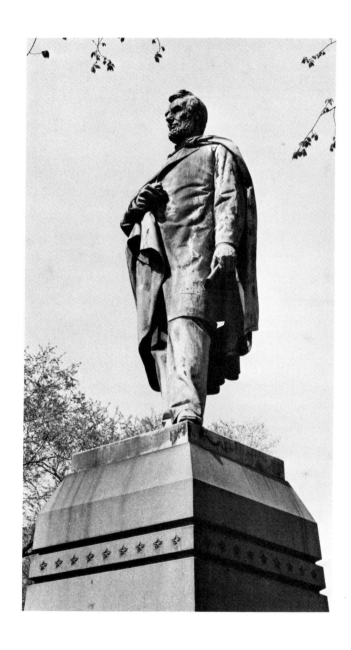

These good intentions, however, can hardly be said to have produced any significant results. Everywhere, in statue or statuette, in portraits as in imaginary subjects, the sole concern was the sterile exercise of the craft itself, producing a triumph of the most dreary academicism, stamping the human form everywhere with the boredom of its rigid imprint.

Surely it was not ambition which was lacking, for every day studios and workshops grew more crowded. But in spite of sincere efforts of a growing group of contemporary sculptors, such as *John Q. A. Ward, Launt Thompson, Augustus Saint-Gaudens, Olin L. Warner, Frederick William MacMonnies, Herbert Adams*, the art of capturing a gesture or of expressing spiritual turmoil through facial expression still awaits the creator whose inspiration will ignite the spark.

American sculpture is infinitely more advanced in the representation of animal life. If perhaps, the concept of the human form was too abstract for an art at its beginnings, the straightforward mechanism of the American intelligence, delighting in those phenomena sharply accented by nature, mastered on the first try an art consistent with its own dynamic tendencies. Like the painters of the period, most sculptors came to study in France.[2] Here, led by a common affinity, they gravitated toward our great sculptor, *Barye*, that most passionate observer of

[2] Many also went to Florence and Rome, there to acquire the deplorably facile mannerisms of modern Italian sculpture. The best known of these are *Thomas Ball* and *William Wetmore Story*; the latter has died only recently.

19. Frederick William MacMonnies, *Bacchante*,
Exhibited in the Paris Salon, 1895.
Courtesy of The Metropolitan Museum of Art,
gift of C. F. McKim, 1897.

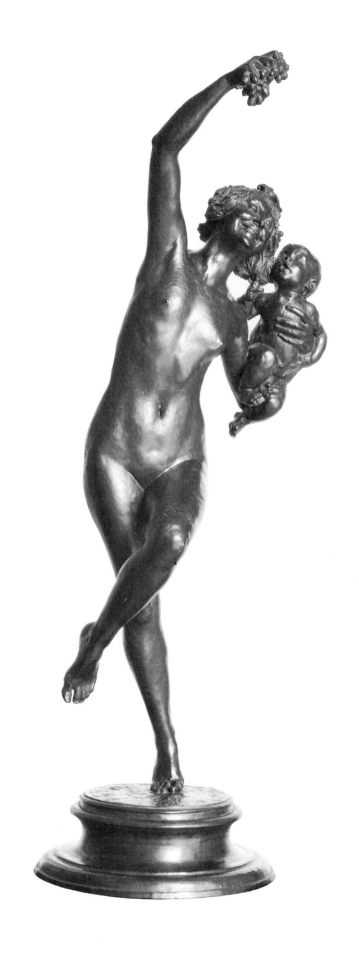

53

nature, who never claimed more zealous disciples or more fervent admirers.

A large part of Barye's work came to the United States, there to proclaim the glory of French art. Let us remember that the principal contributor toward the expenses of the posthumous Barye Exhibition (Beaux-Arts, Paris, 1885) was an American. Henry Walters, who paid this reverent tribute to the memory of Barye, was a Baltimore millionaire who, when transforming his house into a vast museum, open to the public, devoted an entire floor to the work of this greatly mourned artist. What a delightful surprise for the foreign visitor to discover in a corner of America this miraculous collection, consisting entirely of the best examples of Barye's work, a collection unequaled anywhere in the world. This same Mr. Walters erected at his own expense, in the main square of Baltimore, four huge bronze statues by Barye (*Peace, War, Order,* and *Force*). Works by Barye are to be found in every large public museum and private collection in the United States.

We should not be surprised, then, if such an enthusiastic cult served to whet further the American appetite for this kind of art. A large school of sculpture has emerged which, for lack of more lofty inspiration, is still passionately concerned with the secondary beings of creation, and is busy immortalizing, in thousands of lively examples, the characteristic traits of the animal world.[3]

[3] In the last Paris Salon (1895) everyone acclaimed a large collection of small bronze animals with marvelous patina, rendered in astonishingly lifelike fashion by the American sculptor *Paul Wayland Bartlett.*

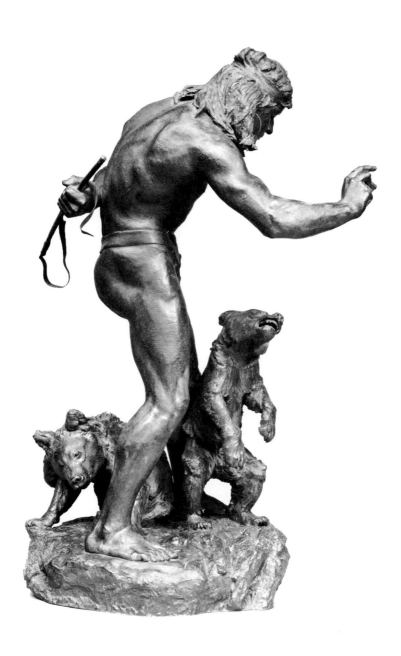

There are other applications of sculptural art, however, still better suited to the particular aptitudes of the American people —the translations of the natural forms of plant and animal life into ornamental language. As yet unable to stand alone, sculpture can still contribute to large decorative ensembles. Her arabesques appear upon stone façades; intricately carved networks on the smooth surface of paneling tease the eye, as it tries to link the architectural to the decorative. Sculpture plays a highly significant role as intermediary between the exalted prestige of Fine Art and the more everyday art of ornament, subordinating itself, by way of contribution, to those principles of unity which must always unite all branches of art in a common effort.

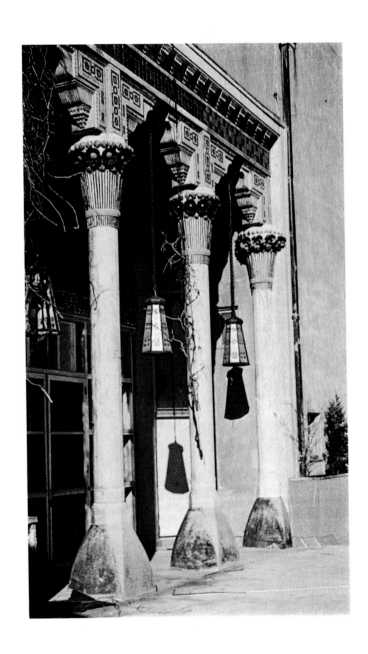

Louis C. Tiffany and Robert L. Pryor,
Columns at Entrance to Laurelton Hall,
Oyster Bay, Long Island, New York, 1902–1905.
Robert Koch Photo.

Architecture

In no branch of art have the American people displayed more overwhelming vigor than in the development of architecture.

The stylistic origin of most building is simply a reflection of the architectural heritage of different groups of settlers. In the course of the seventeenth century, each colony, following its own traditions, built its settlements. Of the buildings from this period, only a small number still stand. Near New York, the visitor can still see a Dutch Colonial church; the town hall of Yonkers, dating from [the early eighteenth century] is another example of this style which is also reflected in the domestic architecture of a few large farmhouses scattered throughout Long Island and New Jersey. Elsewhere, in southern states such as Louisiana and Florida, significant traces of the Jesuit style imported by the Spaniards survive in ecclesiastical buildings, but none of these are of any artistic interest.

By the time the growing prosperity of the colonies had imposed a more ambitious character upon their architecture, the English style predominated. The city of New York (formerly New Amsterdam), becoming an English possession in 1667, was the first to see the red gables and steep roofs of the Dutch give way to less picturesque but more commercially practical buildings. Elsewhere, English style was exemplified by houses destined for gracious country life of the rich tobacco planters of Virginia and Maryland. Such architecture, of which examples still abound, is known as the *Colonial style*, distinctive for great simplicity, a

21. Carter's Grove, James City, Virginia, 1751–1753.
Wayne Andrews Photo.

tribute to the craftsmen who created it, at a period when professional architects scarcely existed. Wood is always the essential element. The symmetrical plan, with two wings flanking the central section, is satisfying in its perfect balance, and on occasion, surprising in its refinements.

For a long while the Colonial style remained dominant. After 1830, however, the idea of following all European styles seized architecture, as it had captured the other art forms.

The Greek Revival then reigned supreme on this side of the ocean; thus, the architects, commissioned to design splendid buildings for the new capital city of Washington, turned to Greece. Ministries, post offices, and many other buildings dedicated to American bureaucracy borrowed their lofty façades in the Doric, Ionic, or Corinthian style from ancient pagan temples. The famous Capitol Building, based upon an antique model and crowned by an immense dome more than 325 feet in height, was calculated more to arouse national pride and the fervent admiration of the masses than to charm those enamored of harmonious proportion. From Washington, the obsession with the antique swept Philadelphia and New York, storming through smaller cities on its way. Churches and houses, town and country, buildings of stone, brick, and even wood began to affect the classical style—happily to last only for the short period of about fifteen years.

After the Greek Revival, a new fever swept American architecture. Once again of English origin, it conquered every taste in the name of the medieval—in this case, a bastard Gothic, frozen, then

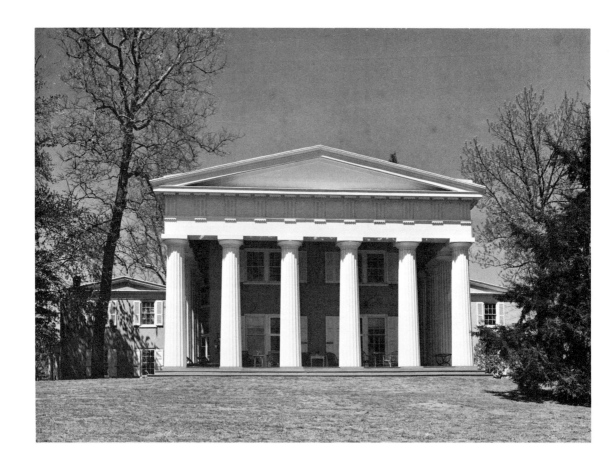

22. Nicholas Biddle Residence, Andalusia,
Pennsylvania, 1833.
Wayne Andrews Photo.

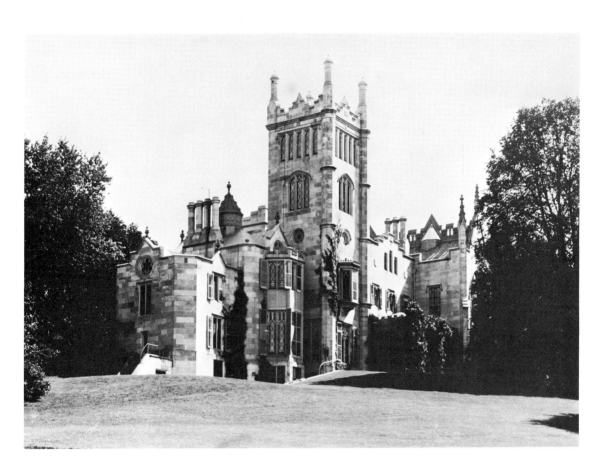

embalmed by contemporary Anglicanism. Although it first monopolized all public building, the Gothic style can only be said to have really endured in ecclesiastical architecture.

In domestic architecture, as might be expected, Renaissance style next became the fashion, and soon thereafter, the elegance of its line and richness of ornament were outlined on the thoroughfares of every large city in the United States.

Never in the history of the human race had cities sprung up so rapidly, with their ever growing rows of buildings. Thus, it follows that swarms of construction workers were always in demand. French, English, German—they came from every country. America, could not, however, forever resign herself to the rather dubious role of a vast modern Babel. As her skills and knowledge increased, she also attracted architects from abroad. Finally, a few of her own young architects, the better to do battle, armed themselves with the enemies' weapons and went to study in Europe. Like their painter compatriots, most succumbed to the attractions of Paris as a brilliant artistic center. But how much more did the architects turn their studies to advantage! As opposed to the painters, who, upon returning home, could add nothing personal to what they had learned abroad, a number of architects were to see theoretical knowledge, not as a final goal, but simply as the preliminary stage required before attempting the lofty regions of personal statement.

In 1846, a student named *Richard Hunt* enrolled in the *Ecole des Beaux-Arts* in Paris as a pupil of *Lefuel.* The master was so

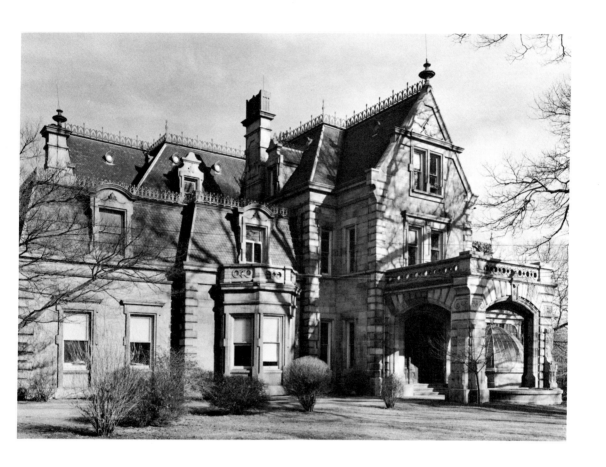

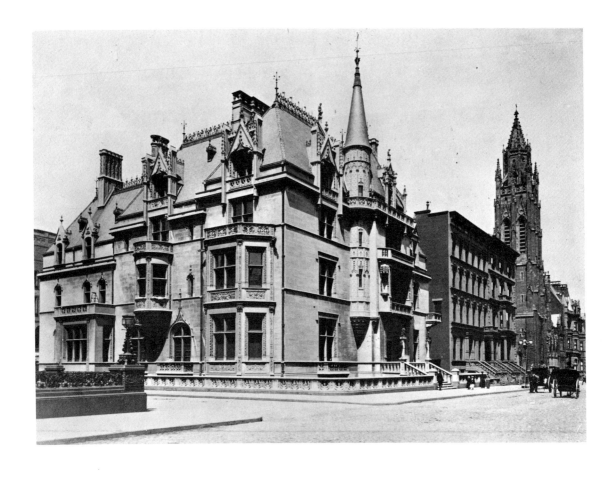

25. Richard M. Hunt, William K. Vanderbilt Mansion,
Fifth Avenue at 52nd Street,
New York City, 1881.
Brown Brothers Photo.

impressed by the exceptional intelligence of the young man that he subsequently entrusted Hunt with an important section in his work for the *Pavillon de la Bibliothèque,* one of several new projects for the Louvre. Hunt profited brilliantly from his training. Absorbing the best French architecture of the past, he felt a particular affinity for sixteenth-century style, and much later, well after he had returned home, and already famous, when he accepted commissions for the vast houses of his rich compatriots, he still remained most faithful to the French Renaissance. But if Hunt only sought to transplant to his own soil the European forms he so much admired, other architects began their career with the fervent desire to foster an art appropriate to the environment from which it sprang.

Among these was *Henry Hobson Richardson,* ranking eighteenth among the one hundred twenty competitors in the examinations for the *Ecole des Beaux-Arts* in 1860. Richardson remained in Paris for six years, during which time he acquired a solid architectural background while remaining wholly faithful to his own resolve. A passionate spirit, he felt the foment of that creative brilliance destined to propagate the gospel of a revolutionary art. There is no saying what the full realization of his role might have been without its denial by premature death in 1886, at the age of forty-eight. In any case, it was Richardson's theories, translated into important works, which demonstrated the utter nonsense of endlessly copying styles from every place and period, none of which had anything in common with the present. Richard-

son conveyed to his countrymen the need for an architecture responsive to the most modern way of life, one taking into account all of the changing conditions of existence. This is not to suggest that Richardson and his disciples intended to renounce all forms of architecture ever created in the past. But they saw the problem as one of finding a point of departure, searching for those pre-existent elements most appropriate and most readily adaptable to lend themselves, under new skies, to the problems of contemporary transformation.

Innovators of centuries past based their work upon the style of their time, which, more or less consciously, they modified. When, at the critical period, an important evolution took place, it had long been prepared by imperceptible shifts of calm and gradual transition. This is hardly the case today. The present century, to its unprecedented shame, has not been able to forge a style of its own. The thread of tradition is broken, and the fragments scattered. Where should architecture begin?

If in the midst of such confusion Richardson felt called upon to reveal new perspectives, this may have been due to a strange phenomenon of heredity. Although imbued with the firm and positive spirit which had made his race so strong and prosperous, sharing the young blood of his countrymen, resulting from the crossbreeding of diverse ancestors, this artist also felt surging within him a dream of art whose mysterious origin went back eight or nine centuries through space and time.

A new formula was to issue from this fusion within one breast of the visionary, who intuitively rediscovers the austere architec-

tural outlines of an early iron age, barely emerged from barbarism—with the fervent apostle of a thousand practical modern refinements. This new formula was the bold return to strong solid form, to the imposing nobility of line that characterized the compelling image of Romanesque architecture, before its slow disintegration throughout the centuries. It was his rehabilitation of those simple patriarchal orders, transformed to meet the requirements of modern living and rejuvenated by new scientific progress which renewed the art of building. [1]

The most active period of Richardson's career began with several great churches. With his first effort, the impressive structure of Trinity Church in Boston, he revealed the full force of his talent.

Trinity Church gives the impression of a twelfth-century basilica, without suggesting any specific precedent. Certain parts seem inspired by a particular church in the Auvergne, others by a Spanish cathedral or Pisan basilica, but all of these elements are fused in a homogeneous, dynamic whole, whose many parts are ration-

[1] Richardson's choice of the Romanesque had nothing in common with a merely superficial attraction. As he saw it, there was a hidden relationship, a supernatural affinity which joined his own spirit to that far-off and primitive civilization. After his return to the United States he never again saw a single important Romanesque monument, with the exception of very poor photographs. And when, seventeen years later, he traveled through Southern France, Lombardy, and Spain, he conveyed his astonishment with an innocence so disarming that we immediately forgive its naïve presumption: "how those old fellows had done the things I have been trying to do myself." *
* Editors note: M. S. Van Rensselaer, *Henry Hobson Richardson and His Works* (Boston and New York, 1888), p. 35: "He often spoke of the singular delight it was to see 'how those old fellows had done' the things he had been trying to do himself."

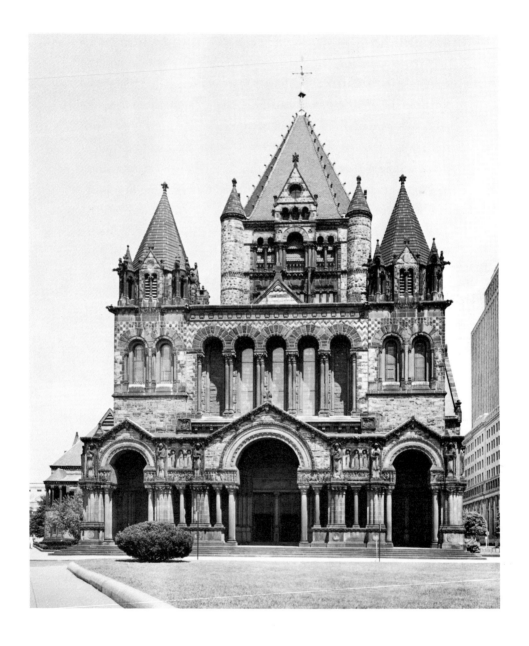

26. Henry H. Richardson, Trinity Church,
Boston, 1872–1877.
Wayne Andrews Photo.

ally subordinate one to another, in accordance with their func-
tion.[2]

As we enter the church, its appearance changes. Without fur-
ther reminders of borrowed elements the boldly arched vaults
reach proportions which could hardly have been attempted with
primitive methods of construction. The walls vibrate with poly-
chromed ornament whose color and design is subordinate to the
style of the building. The windows represent an important decora-
tive decision. In addition to several commissioned from the Eng-
lish painter, Burne-Jones, we find glowing windows designed by
the famous American colorist John La Farge—superior examples
of an art form revived in the United States and which we shall
discuss in detail in the next chapter.

Trinity Church is the most important of the several churches
that Richardson left to Boston. Among the others, we should note
the Brattle Square Church, surmounted by a lovely steeple of

[2] Constantly preoccupied by this project throughout the entire period of construction
(1872–1877), Richardson never stopped reworking his earlier ideas. He came to be
especially dissatisfied with the tower as originally conceived and presented in his ini-
tial competition design. His doubts became most acute at just the time when the tower
alone remained to be built. The builders were impatiently awaiting their instructions
when Richardson, sick in bed, received a series of photographs sent from Europe [by
John La Farge]. Looking them over he became wildly excited. "This is what we
want," he said, waving a reproduction of the tower of the Cathedral of Salamanca
[Marianna Schuyler Van Rennselaer] *Henry Hobson Richardson and His Works*,
Boston and New York, 1888). The tower of Trinity Church subsequently received its
quadrangular shape, divided in two stories, flanked by angle turrets and crowned by
four gables and an octagonal pyramid roof. But a total change in the proportions and
ordering of the colonnade and of the entire exterior ornament made these elements
accord with the rest of the church, which seems conceived as a totality. Few modern
monuments are as strikingly impressive.

Florentine style, for which reliefs were commissioned from Bartholdi, the French sculptor, after the architect's designs.

Richardson was subsequently attracted by secular architecture. If he had lived at another time and place, and with the same spiritual bent, religious art would undoubtedly have absorbed his entire genius. But his perception of contemporary life was too astute to allow him to believe that his country was seriously concerned with celestial matters.

No other country in the world follows traditional religious observances more faithfully; nowhere is dogma venerated with such conscientious obedience than in America. For its people, in whose veins Puritan blood still flows, religion is an obligation to be discharged—although a sacred obligation it is—no more than that, and as such, exempt from all passion. America inherited our already ancient religions. She has not, as yet, had any religion emerge from within her own culture. There has not been, nor will there ever be, in America a movement of universal worship and impassioned faith, akin to Christianity after the year 1000, one of those great periods of religious intoxication, without sacrifice too extreme for the simple piety of the people, inspiring countless superb basilicas, cathedrals, and churches. In America, religion is only a legacy, to be handed down intact, from one generation to the next.

In a country where everything constantly changes on the highway to the future, jammed by a ceaselessly striving humanity, where no moment of rest, nor backward glance, is allowed those

who do not want to be left behind, religion is the only immutable element. For the future belongs to those who, to greater or lesser degree, support the pursuit of this double objective: the conquest of vast wealth and the search for the most perfect means of increasing the pleasure that money can give. Everything is invented with a view to the improved mechanism of business, everything that leads to a maximum of results with a minimum sacrifice of time is bound to succeed.

What better conditions could architecture hope to find? Before it lay a unique situation and the chance to play an unlimited role. The rapid transformation of every building which served the thousand needs of daily commerce—offices and warehouses, administration buildings of every kind, stock exchanges, hotels, and railway stations; the remodeling of private houses, city or country— all coincided with the staggering accumulation of wealth and a growing refinement of taste.

In commercial centers the old structures no longer fulfilled present needs, and the number of buildings—too few for the increasing number of employees. Each day this mounting tide sought to annex a new parcel of land in the heart of the teeming old section of the city where all of the commercial buildings were crowded around the stock exchange, just as in earlier times, peaceful towns sought shelter at the base of their guardian cathedral. But finally, this state of things could no longer endure. In New York, especially, built upon a long narrow peninsula, the congestion becomes acute. The price of land around the harbor reached

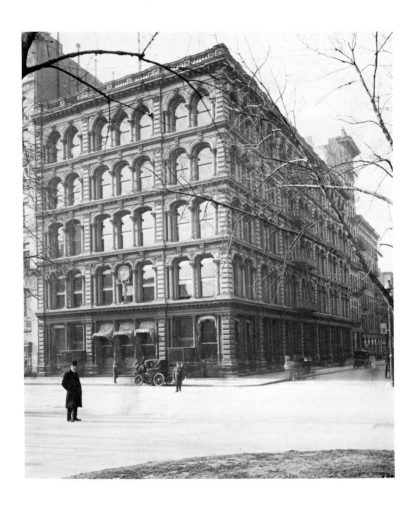

27. John Kellum, Tiffany & Co. Building,
Union Square, New York City, 1870.
Courtesy of The New-York Historical Society,
New York City.

such fantastic proportions that its equivalent in silver coins would have covered twice its surface.

A solution had to be found. Perhaps the remedy emerged from the urgency of the situation, or else its discovery may have been dictated by one of these happy conjunctions that cause an unexpected need to coincide with the means of fulfilling it. In any case, we can certainly speak retroactively of the interplay of cause and effect.

With space for the juxtaposition of buildings rapidly disappearing, American architects began to envisage superimposing them, one upon another. But these bold plans would require as yet undreamed of technical resources. Problems multiplied. To begin with meeting the most basic of requirements, the structure must be sufficiently light to avoid the possibility of its sinking into the often unresistant ground. A safe and rapid method had to be found for reaching the upper floors; fire extinguishing and escape devices were needed to insure the safety of those on the floors above. The discovery of new construction materials; the use of iron, in particular, for a host of purposes, and its ability to provide the complete framework of buildings were all developed to the requisite degree in recent technical advances.

For more than thirty years, iron had been used, but in a very timid way. Now four beams were erected at right angles to one another, to which four more were then riveted, interesected by transverse beams, a process then repeated according to the desired number of floors. Thus, in almost no time at all, there rose an enormous metal cage whose qualities of resistance allowed for

the thinnest possible masonry composed of hollow, fire-clay bricks.[3]

A building so constructed is not only fireproof (as the new term has it) but the thinness of its walls has the further advantage of saving ground space. The height of the buildings increases daily. At first they were ten stories high; now buildings of twelve, fifteen stories and more are commonplace.[4]

No more staircases. Depending on the size of the building, one, two—going as far as eight or ten—elevators—electric or hydraulic, climb at a rate of roughly 12 feet per second, carrying waves of visitors into long galleries where, one after another, hundreds of businesses of every kind are represented; storerooms for raw or manufactured materials; banking and brokerage offices; lawyers; accountants; stockbrokers, engineering firms and advertising agencies—vast complexity to create convenience, constant simplification for the hurried businessman who can find under one roof the thousand and one gears required to run a commercial machine.

So conceived, the ideal model for a commercial building comprises a rectangle, pierced with windows at uniform intervals, distributing to each compartment its fair share of light, without

[3] To illustrate the dizzying speed of these transformations, I was told the following story, apocryphal perhaps, but revealing nonetheless: Returning to New York after a brief absence, a resident noticed that during this short time his old house had been demolished, and replaced by a palatial new structure, housing a company which had just enough time to go bankrupt by his return.

[4] The last few years have seen buildings rise as high as twenty floors and beyond. But one consequence of this endless progression is that iron has now become too heavy; steel is being tried as a substitute, and the time is probably not far off when aluminum will be used, as its cost has dropped rapidly in recent years.

28. Daniel H. Burnham & Co., Flatiron Building,
Broadway at 23rd Street, New York City, 1902.
Courtesy of The New-York Historical Society,
New York City.

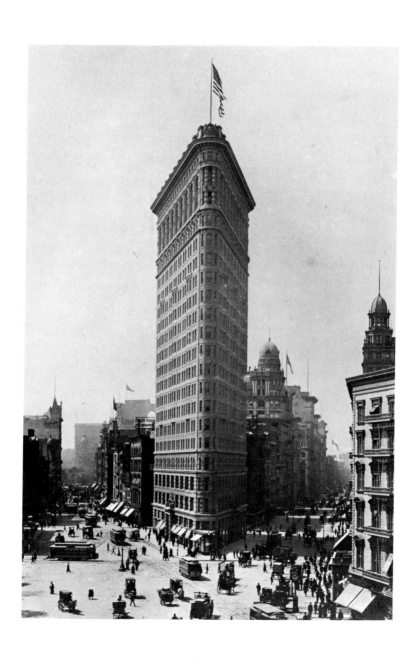

losing an inch of space. The same desire to exploit space has prevented builders from lightening the appearance of the upper stories by means of a receding profile. And when we note further that large entrance ways, loggias, or balconies are rejected for the same reasons, it will be concluded that the proliferation of this kind of building must result in a cold, horribly monotonous city.

But here, above all, the American has given free rein to his most practical impulses, imposing the principle that the basic obligation of everything is to serve rigorously the function for which it was conceived. A commercial building exists for commerce and for no other reason; no additional aims should detract one iota from the utilitarian function incumbent upon it. Such considerations, however, were soon complicated by the equally strong desire to help business transactions take place as smoothly, quickly, and even comfortably as possible. By using the most sophisticated systems of heating, ventilation, and the most advanced hydraulic engineering, ingenious improvements found their greatest results in telephone and electrical services. But when at last it became apparent that practical needs had been fully satisfied, the active and convenient flow of commerce facilitated, the desire to create beauty returned. At this point, it was purely a matter of luxury, but a luxury whose aim it was to increase the prestige of business, to become that most intelligent form of advertising, whose attractive appearance proclaims it to be a center of privilege and dispenser of fortune.

The huge insurance companies, and powerful newspapers, had been the first to want splendid and imposing offices, buildings in

which only the most precious materials were used. A thousand varieties of marble, granite, and red porphyry were quarried from American soil, and more arrive by the boatload from Italy, Ireland, France, and even the Ivory Coast.[5]

But in the rapid succession of such changes, America had already begun to suspect that Beauty might have sources other than the use of sumptuous and costly materials. The realization dawned that elegance is not a matter of wealth alone, and that beautiful materials acquire their aesthetic value only when seen as a complementary element in a harmonious whole. People of intelligence felt an undefined need for greater refinement.

In the midst of this foment of progressive ideas, at this eminently propitious moment appeared Richardson and his disciples, with a program as original as it was practical and aesthetic: to develop the most useful innovations conceivable, whose practicality would be enhanced by artistic quality. This was the problem they sought to solve.

Not least surprising was the revival in these secular buildings of the austere styles whose solemnity, conceived to house sacred mysteries, might seem displaced as now applied to temples of commerce. Certainly, nothing could be stranger than the resurrection of Romanesque building principles—a Romanesque tempered by the Byzantine with occasional Quattrocento elements— in the modern form of a famous bank, department store, or showroom for colonial imports. Nor could there be found any greater

[5] The annual imports of marble to America amount today to several millions of dollars.

contrast than these somber, massive exteriors, in the midst of the swirling life of a noisy, modern city.

More often, it should be added, only the ground and first floors were in the Romanesque style. The base of the building was overwhelmingly massive in form and faced with the heaviest and most solid material possible. And from this powerful stringcourse, pierced solely by a main entrance in the form of a low elliptical arch resting upon short thick columns of colored marble or granite, spring arcades twenty-five or thirty feet in height, their delicate strength enclosing as many as five, six, or even eight stories of windows. Still higher, a different motif begins its ascent, to be replaced in turn by a row of airy bays, terminated by a simple, solidly built cornice.

This describes one of the most widespread and successful examples of such building among the vast and imposing multitudes. As a type, it is far from fixed, since each day brings forth new experiments and changes, but we can safely say that, as of now, America has succeeded in imbuing its commercial architecture with the dominant spirit of the race, a spirit that delights in undertakings of powerful scope, conceived at the opportune moment and boldly pushed to the extreme.

Considered now from the rather special point of view of aesthetics, should we be pleased to see such creations rising everywhere? Do we perhaps delude ourselves in hailing them as a new art form? Further, are we not corrupting the word art, in its highest sense, when we apply it to these vast commercial buildings

where everything is planned, calculated, and contrived in the interest of materialistic speculation alone.

Art is embodied here no less than in the loftiest abstractions. Bearing in mind precisely the highly practical nature of these commercial buildings, and above all, the fact that they are built by a people as yet inexperienced in aesthetic matters, we need only think with horror of the barbarous creations that might have arisen. Consequently, by simply acting to prevent the hideous, art has already fulfilled a mission, no less important or even noble, than the creation of Beauty on better cultivated soil.

Such efforts, moreover, have borne results meriting more ample discussion. No one could remain unmoved by these cyclopean structures that rank among the most eloquent and grandiose expressions of human energy, solving all of the great problems at just the time when unforeseen needs had created them. Once we acknowledge that abstract concepts are not the sole refuge of Beauty, that if certain practical products may borrow a share of poetry from the very magnitude of the efforts required to create them, and of which they become the significant symbols and if, furthermore, art can consist in establishing a harmonious accord between the external appearance of things and their inner significance, between their rationale and goal, then it is undeniable that perfection has been achieved where man, to attain his objective, has conquered an entire realm of hidden forces which, from the very beginning, lay dormant at the very core of matter itself.

To ensure an impartial judgment, we must also be able to envision a work from its own vantage point; instead of seeing things

in isolation we should also consider those aspects borrowed from their surroundings. If, by some miraculous occurrence, one of these gigantic structures were suddenly to be transported to our own land, it would seem a monstrous paradox, a violent rupture with every familiar sight.

But, if a second magic stroke should deposit us upon the shore of the United States, where the panorama of New York City rises before us, teeming as far as the eye can see upon her narrow slip of land, a dark breakwater in the blue of an immense bay—if before us should spread that infinity of space, water, and land merged in a chaos of throbbing life, where multistoried steamboats, horses, noisy tugs, and huge ferries transporting trucks by the dozen, where to reach the railroad on the other side of the bay we sail for an hour, our train with its passengers, freight cars, and locomotives loaded on board a ferry, where, as we make an almost complete circle of the city, we pass dock after dock, construction after construction site, swarming barges and thousands of warehouses, the beginnings of avenues rumbling with noisy streetcars, while above, elevated trains shoot into the distance, where we cross (our railroad car above the water) the spans of a vast bridge, 162 feet [*sic*] high, where strident motors, streams of traffic, the crush of people below seem a fantastic scattering of miniscule toys; in this unique place, where Bartholdi's great bronze * is only a knickknack upon a shelf, our vision becomes so imbued with the relative scale of things . . . that far from accusing American

* Editor's note: The Statue of Liberty.

artists of stretching the limits of just proportion, we see that these gigantic structures are in perfect keeping with their surroundings.

Finally, to continue with aspects of New York City, we can agree that the picture, to be really complete, cries out for domination by that silhouette of dense masses—and that it seems to have taken no less than the supreme triumph of commercial power to have summoned forth from the sea itself this great market place of every ocean, to imprint its decisive character upon this most compelling image of human activity, extending the entire breadth of its noble lineaments into the vast horizon of a matchless panorama. [6]

In other important centers, like Chicago, the impressive effect of public life is no less in harmony with the proportions of the immense commercial palaces.

We should also remember that the large public thoroughfares, always planned for spaciousness and breadth, enjoy the benefits of exceptionally fresh air, an advantage entirely unknown to our European streets, all too often lacking either air or light.

The American, however, does not limit the field of his activity to the citadel of his business alone. With prodigious mobility, and at the first incentive, he moves from one part of the country to another. This taste for change is facilitated by the number of rail-

[6] For the present, these splendid vistas have not yet been completed everywhere. As new structures are built here and there, without preconceived order, they rise in the midst of small old buildings like fortresses surrounded by peasant hovels. The impression is one of vibrating lines and a certain sense of confusion that distracts the eye, and will remain a cause of irritation until such time as those sections which have begun to be razed for new buildings have been entirely rebuilt.

roads, all in active competition, and serving, in parallel lines, the same regions. Their constantly increasing number has led to the building of new stations, some very handsome indeed, in the larger American cities. Notwithstanding the soaring thrust of their vaulting, the vast American city station can no longer fill us with awe, since we have already seen in Paris the powerful forms of our noble *Galerie des Machines** take shape on the Champ de Mars. By ironic paradox, however, instead of impressing us by new feats of iron casting or mechanical genius, America, so famous for her separation of the functional and aesthetic, this time sets a shining example of good taste, which we would do well to follow, if we could only rid ourselves, alas, of some of our most cherished habits.

When, far from the city, the French traveler is at last surrounded by nature, his gaze avid for rustic beauty, he is constantly shocked to see, rising before him at every station, still another of those ugly, sterile, angular buildings that, forming a tiresome extension of the city, seem to pursue him obsessively over valley and hill, through forest and wood, extending to the farthest reaches of the hundred thousand tentacles of our railway lines.

America, on the contrary, has protested this barbarism of shattering the harmony of a peaceful setting, and it was Richardson, once again, who prompted this reform by proclaiming the following truth: suburban and rural stations should not try to resemble some sort of house, but should instead define their true function—

* Editor's note: Exhibition hall for the Paris Exposition of 1889. Demolished in 1910.

providing a place to wait, a brief shelter for transient guests, calling for few partitions and the lowest building possible, with the essential front section a continuation of the shingle roof. The overhang of the roof itself is prolonged in a series of sheds and open porches which alternate with the closed sections. The entire structure, however, is built with the utmost solidity. The rustic effect results from the picturesque disposition of lines, as in certain English cottages, not from any attempt at lightness, based upon a use of fragile materials. It is even more astonishing to observe how the massive gravity of archaic forms, so dear to the entire Richardsonian school, has been adapted to this small structure, without sacrificing any visual pleasure or conformity to the desired rustic character. On occasion, a large bay, whose semicircular arch springs directly from the ground, is opened in the compact and low masonry to provide a sheltered access for vehicles. No superfluous ornament, only the obvious effort to impart a sober and artistic flavor to the whole building, down to the most minute detail.

One hardly need add that small stations of such originality have not been built in vast number. But they deserve mention here as promises for the future. Nevertheless, these stations do exist in New England, notably in North Easton, Chestnut Hill, Auburndale, Holyoke, Woodland, etc.

Financial pressure is not a prerequisite for this kind of progress, but competition is keen among these railroads, not only for passenger fares and speed of trains, but also as revealed in the countless efforts expended in the interest of passenger comfort

29. Henry H. Richardson, Boston & Albany Railroad
Station at Chestnut Hill, Massachusetts, 1881–1884.
Wayne Andrews Photo.

and enjoyment. And in fact, the ultimate degree of luxury and comfort found on some American railroads is by now world famous.

Similar standards of well-being today extend to everything concerning travel in the United States. For example, hotel accommodations in important cities, primitive for so long, have responded to contemporary requirements. And the result, naturally, is that hotel living finally provides so much in the way of facilities, that many families, even within their own city, prefer it to the bother of housekeeping. [7] Even in this domain, however, architecture still has myriad problems to solve. The fortunes spent in the building of hotels in a city like New York have mounted within the space of a few years to almost unimaginable proportions. Some hotels have absorbed millions of dollars. [8]

Such lavish expenditure is not often likely, by its very nature, to produce results of very high quality, results that would not, in any case, be an accurate reflection of the questionnable taste of most travelers. These attempts did, however, result in some felicitous innovations; so much thought has been expended in the search for improvement that the whole is finally far superior to

[7] To find a compromise between this freedom of existence and the intimacy of domestic life, houses of twelve or fifteen floors have been built in the most fashionable neighborhoods, each floor comprising an elegant apartment without any kitchen. An enormous restaurant on the ground floor is maintained exclusively for the tenants.
[8] The huge Waldorf where $160,000 (800,000 francs) worth of marble was used in the facing of interior walls, and $200,000 (one million francs) were spent on carpeting alone, is now eclipsed. $30,000,000 capital (150,000,000 francs) has been invested in a rival establishment, to be erected on Fifth Avenue.

the finest hotels in Europe. Further, without even mentioning such sophisticated refinements as a private bath for each room, one is struck once again by the accord between these massive projects and the grandiose scale of life around them. The exuberance of things and of life go hand in hand, in perfect rhythm; nothing seems discordant, however excessive the pace. After the visitor has recovered from his first state of shock, no sight can further astound him, until he reaches the point where everything seems perfectly natural—even such phenomena as the interaction of multiple elevators carrying hundreds of waiting guests from the lobby, whisking them in five or six seconds to a large dining room on the tenth floor!

Of all American hotels, perhaps the most unusual is in Chicago. Part of an enormous structure called the *Auditorium*, it exemplifies the point to which the American is able to combine his desire for luxury and pleasure with the safeguarding of his financial interests. Let me describe the project and its genesis.

Chicago yearned to have a great opera house, worthy of competing with the finest in the world. But the city wanted this luxury without taxing its budget. The architect, Louis Sullivan—like Hunt and Richardson, a student at the *Beaux-Arts*, and like them, an innovator of new formulas—found the solution to their problem.

Sullivan designed the building in the form of a rectangle, surmounted by a quadrangular tower 295 feet high. Those façades facing the street were reserved for hotel space, with business offices located in the tower. There is no corner of the building,

from the basement to the very top of the tower—in all eighteen stories with over a thousand windows—of which some use has not been made. Thanks to this ingenious combination, the costs of the undertaking are being recovered over the years by the vast theater at the core of the structure.

As soon as we enter, we can imagine the enormous difficulties to be resolved in the building of a hotel that encloses a theater. Notwithstanding the restrictions of this anomaly, all the public rooms give a monumental impression, especially the main dining room, more than 195 feet high with splendidly vaulted ceilings, and providing, from its tenth-floor setting, an admirable view of Lake Michigan; the banquet hall, boldly suspended, by some miracle of balance, above the immense space formed by the theater, and conceived in a richly inventive and altogether personal style. The impressive lobby with its semicircular arched portals and low colonnades is further enhanced by completely original sculptural decoration, based directly upon plant forms. The finishing touch of the decor is provided by an intriguing disposition of electric lighting fixtures, which play an active role in the harmony of the main architectural lines.

But it is the theater, above all, the Auditorium itself, which stimulated Sullivan's creative genius. No other part of the building reveals as firm a will to sacrifice superficial glamour to the practical demands of the enterprise. Not merely content to have renounced the luxury of a façade, subject to the budgetary restrictions of his program, Sullivan also sacrificed every other consideration to solve the great problems of acoustics, comfort, and flow

of traffic. He did not hesitate to eliminate certain visual effects, no matter how beautiful, if they interfered with his aim of the best possible acoustics for the one thousand members of the audience. Thus, starting with the entrance itself, the visitor is disappointed by certain peculiarities of construction. The ceiling, in particular, which starts out low on the stage side, fans out toward the back of the auditorium to terminate in the right angles of a vast rectilinear wall, against which the balconies are stacked. Four elliptical arches were thrown across the parquet space. These arches, graduated in size, deflect the sound and are, at the same time, beautiful architectural forms, accentuated still further by cordons of electric lights. Semicircular arches, also helpful acoustically, following the outline of the boxes, climb to the highest parts of the ceiling whose vaulting is magnificently impressive. Large openings filter the crowds into rows of spacious corridors, lobbies, well-organized cloak rooms, to the numerous washrooms and ample stairways, while a powerful ventilation system and ingenious methods of air-cooling always maintain a comfortable temperature. The functioning of the stage is no less noteworthy. By means of the most skillful use of hydraulic machinery, the floor can be lowered 20 feet in depth, either in its entirety or in sections, and since the basements, consequently, had to be dug at a level deeper than the nearby lake, only 1000 or 2000 feet away, a vast amount of labor was necessary to insure against flooding.

Chicago is not the only city to be graced with this kind of multiple function building. Among others, New York has the

huge Equitable Building, constructed by the famous insurance company, which contains, besides its offices, meeting rooms of every kind, clubs, and huge restaurants. In the admirable Chamber of Commerce building in Cincinnati, the entire ground and first floors are occupied by banks, shops, and a restaurant, while the second floor is taken up by a vast conference room 52 feet high by 160 feet wide; then, suspended above this immense space, four other vast floors divided into rentable office space cling to the roof.

Within a very short time, the need for renovation engulfed every kind of building. There was no longer a state or city that did not crave a senate, civic buildings, and courthouse, all built according to the latest methods. And the same innovating spirit swept universities, public libraries, art schools, and museums of art or archaeology. Institutions everywhere outdid one another to strike the most modern note, and frequently, in an attempt to be the last word in sumptuous appearance, no expense was spared. The most beautiful buildings, however, were not a corollary of the largest expenditure.

One of the most eloquent examples of disparity between exaggerated spending and quality of result may be seen in the state capitol in Albany. Its construction costs amounted to more than $20,000,000 (100,000,000 francs) [*sic*], its façades extend to a length of more than 420 feet, and yet, in spite of these factors, it gives no impression of real grandeur, perhaps because of the unhappy mixture of styles.

Begun in 1863, and based upon French Renaissance style (Francis I) its ordering was seen to be a horrible mistake as soon as the first two stories were completed. After endless wrangling and indecision, it was decided to dismiss the architect, *Thomas Fuller,* and to replace him with *Richardson* and a young architect by the name of *Leopold Eidlitz*. The latter did not hesitate to complete the Renaissance beginnings of their predecessor in Romanesque style. They vociferously denied this to be any indulgence on their part of their own taste for primitivism, insisting it was the only way of saving this vast project from total failure.

Happily, jarring combinations of this sort were fairly uncommon. The principles of unity were, almost everywhere, faithfully observed. In the city of Albany itself, adjoining the ill-fated capitol building a beautiful and highly original city hall, completed in 1880, displays its pure and homogeneous lines.

Of all municipal buildings in America, the most perfect example is unquestionably the new Pittsburgh Courthouse, begun in 1884 and based upon a Richardson design. This building, Romanesque in style, proved more than any other that clear comprehension and brilliant inspiration could renew the forms of another age, shape them to present day traditions, adjust them to practical needs—all without vitiating their nobility of character or destroying their synthetic unity. Overlooking the entire city from the top of a high hill, this courthouse does not contain a single stylistic element that does not also correspond to a utilitarian function.

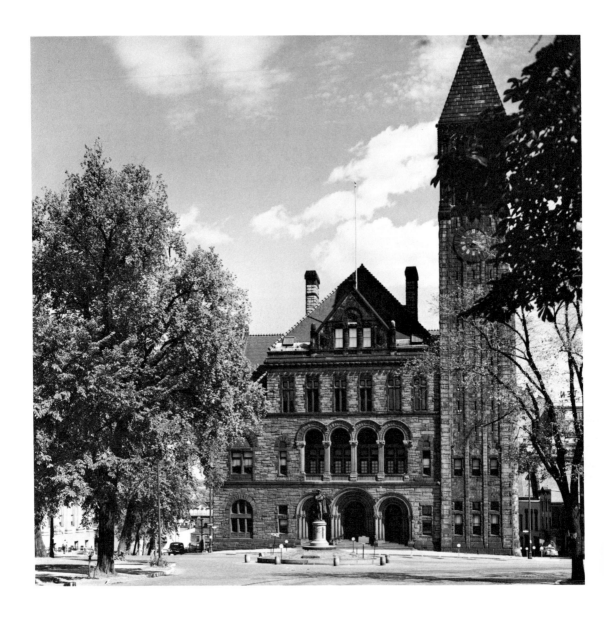

33. Henry H. Richardson, City Hall,
Albany, New York, 1880.
Wayne Andrews Photo.

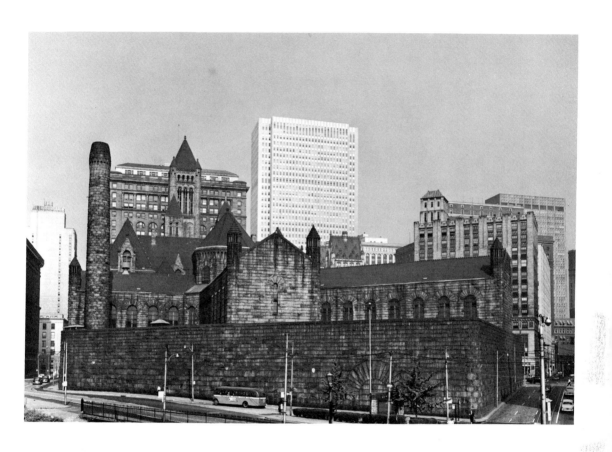

Its three stories enclose a vast rectangular courtyard; the building is flooded with light through a system of high bays, piercing the walls on both sides. The courtyard itself is striking for the corbelling of its four massive towers, each one concealing, beneath a picturesque exterior, the prosaic machinery of an elevator. From the gables of the main façade, rises a symbol of the civic power holding sway behind its walls—another beautifully proportioned tower, whose elegance is further enhanced by four angle turrets. The central tower, divided into five floors, is used for the storage of archives, two of the turrets are elevator shafts or stairwells, while the others provide an ingenious form of ventilation. Like the heating and lighting systems, this ventilation process is based upon radically new methods. Air currents, drawn inside by artfully placed openings at the top of the tower at a distance of about 250 feet above ground, are filtered through several machines that purify them while maintaining the desired degree of warmth or cold. Seen from the outside, each section of the building exemplifies in its proportions the importance accorded its internal functions. Nonetheless, the real fascination of the Pittsburgh Courthouse still lies in the total impression. The principal lines, analyzed separately, are indeed derived from the Romanesque, but the symmetrical grouping of the masses suggests the Renaissance style; the refinement of form in particular echoes the elegant palaces of the High Renaissance.

Several examples in the field of educational buildings commend themselves to our attention. The Woburn (Massachusetts)

Library, near Boston, is one of the most noteworthy. Even here, we see evidence of overblown style, with its abuse of ornamentation, especially out of place among the modest wooden houses which line the streets of this peaceful middle-class town. Conversely, no building was ever more appropriate in terms of function; no structure could display greater balance, simpler or nobler linear harmony than the impressive classroom building of Sever Hall, constructed for Harvard University (Cambridge, Massachusetts). The charming Crane Library in Quincy, Massachusetts, of the same period, also merits special mention. Although based upon a somewhat top-heavy Romanesque order, its different sections are brought together into such a compact and perfectly planned mass that the final result is an unqualified success. Sculptured wood ornament enhances the interior, characterized by both force and grace. This sparkling decoration, running the length of the cornices, playing about the pilasters, winding around capitals, is based, like the rest of the style, on the Byzantine. But the elaborate detail of its diverse motifs is freely borrowed from the plants and flowers of the surrounding countryside. And thus, in this small, pretty library, we make the discovery of a new school of artisan-sculptors, founded only a few years before, and who provide living proof herewith on the vitality of their talent.

If the world of commerce piled floor upon floor in a constant effort to increase ever-shrinking space to fit the needs of its feverish activity, quite different tendencies prevailed when it came to

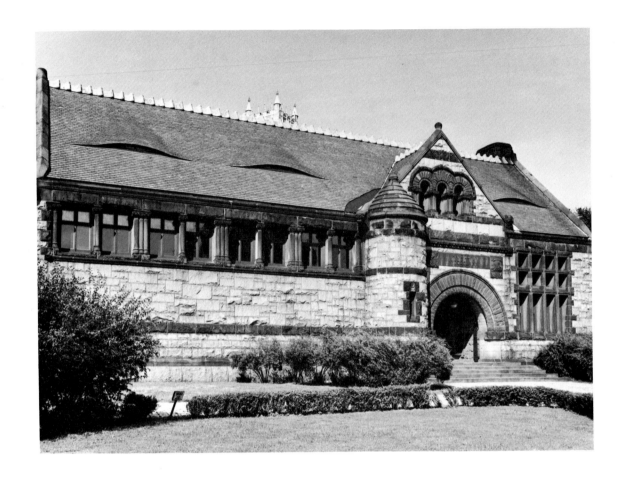

35. Henry H. Richardson, Crane Memorial Library,
Quincy, Massachusetts, 1883.
Wayne Andrews Photo.

domestic architecture. There, in place of buildings two or three times higher than their European counterparts, the reverse held true. Unless the option was for hotel living or boardinghouse life (following a fairly widespread custom among the middle classes), each man wanted a home of his own, however modest.

His working day ended, the struggle briefly halted, each evening provides for the American the welcome contrast of a quiet and untroubled retreat. Thus, nothing could be more dissimilar to the turbulent centers of big business than the outlying sections of the city, where houses squeezed next to one another try to affect the appearance of isolation.

Stretching the length of long quiet avenues, these rows of houses follow each other in monotonous outline. Up until the very last few years, and even in the most fashionable sections of the great cities, one saw the same inexorable procession of narrow façades, invariably undistinguished in style—every stoop of six steps measuring half the width of the sidewalk, each with its double balustrade of wrought iron, always the same. The smaller inland cities still retained picturesque aspects of the colonial style in their old wooden houses. But on the eastern seaboard, in the heart of the major cities, the houses all reveal their English heritage without the slightest trace of any individual taste. Clever speculators built entire streets according to one set of specifications.

It is a strange phenomenon indeed that this people, always reputed to value the greatest amount of display, should allow so many generations to elapse before anyone should seek the means of distinguishing himself by the pretentious splendor of his house.

Even today, when, through the contagion of our example, the taste for spacious living quarters has begun to spread, the sober customs still prevail more than one might think. In America, few private houses—or at least town houses—make any pretense of being ostentatious palaces. With almost unfaltering logic, all of these houses affirm their sincerity of character; they are private houses, and so they wish to appear.

Americans have now ceased to accept simple-minded formulas and ready-made buildings from the hands of the contractor. Today, everyone wants to arrange his home more or less according to his taste and to the kind of life that best suits him.

It was only after the Civil War that these new ideas gained currency. The development was very similar to the progress observed in the area of commercial buildings. First and foremost came essentially practical innovations; next the need for efficiency and comfort, until finally the most enlightened people sought visual satisfaction from the aesthetic arrangement of their surroundings.

In exterior style, the first beautiful houses copied Renaissance types, and especially, under the influence of Hunt (the talented architect already mentioned) the style of Francis I; but shortly, the Richardsonian School, having triumphed in every other domain, moved in to transform domestic architecture as well. From New York to Chicago, from Boston to Philadelphia, during a fifteen-year period (1875–1890), hundreds of houses sprang up everywhere, which, large or small, incorporated eleventh-, twelfth-, thirteenth-, or fourteenth-century architectural features.

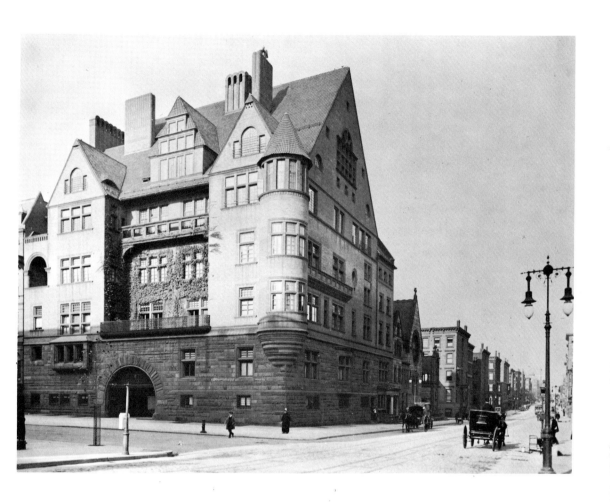

This time, however, rumbles of dissent could be heard which questioned, first, the justification for this strange predilection for austere forms, and second, the degree of discernment with which they were used. Critics further questioned whether these massive forms were appropriate for middle-class houses, and whether, indeed, it made any sense to confer such somber character upon the most luxurious residential neighborhoods—areas that should ideally contribute to the beauty of a city by their example of graceful, festive elegance.

As all too often happens, the most radiant phenomena usher in their darkest counterparts, thus limiting the duration of their brilliance. So Richardson's heritage fell into less able hands who corrupted the master's doctrines by gross overstatement.

Domestic architecture, however, was no more prone to a tiresome, undiscriminating pastiche of earlier styles than had been ecclesiastical and civic building. With no less art, but equal skill, long abolished forms were once again revived in accordance with new canons of living, shaped to contemporary needs. Moreover —and perhaps most surprising of all—no disturbing sense of paradox emerges between the appearance of these houses and their function; no real contradiction between the cold impression made by their high walls and the intimate warmth they were designed to shelter: "Be on your way" their forbidding appearance warns the curious passerby: "This is not for such as you."

But even if overrusticated walls, crushingly pompous portals, roofs in the form of fire extinguishers—if all this fortress fakery gave the master of the house the comforting sensation of a cosy

home, inaccessible to intruders; if the fortunate visitor, the grim
threshold crossed, and once admitted to the charmed family cir-
cle, was there to enjoy the seductive contrast all the more; if,
finally, the structure of these houses was superior in every detail,
and the whole in perfect keeping with the preservation of a patri-
archal tradition,[9] their abuse of feudal forms would be no less
unfortunate. For ultimately, each one of us, without being ex-
pected to renounce his personal tastes, bears a certain measure
of responsibility for the common good.

In the course of things, however, cities were being built whose
brutal aspects clashed with the modern era. Certainly, the ob-
server might be delighted here and there by the picturesque ap-
pearance of some vast façade or by a quaint, unexpected evoca-
tion of an old manor house, more often still embellished by some
felicitous and surprisingly inventive touch. But it was a great
mistake to make such indiscriminate use of these anachronisms,
to the point where they burdened the modest dimensions of ordi-
nary houses. The inability to place rational limits on the use of
this style has caused the beginnings of serious reaction today.
Architectural fashion has already turned to the sixteenth century,
and the newest buildings, although unquestionably elegant, are
really nothing but more or less successful pastiches. If America

[9] We should be wrong in attributing the astounding precocity of American children,
or their uninhibited emotions and conduct, to any weakening of family ties. If the
father permits this behavior in his children, this stems from the conviction that noth-
ing could better prepare them for the frantic hurly-burly of life. The truth is that the
American's most cherished desire, at the end of the day's work, is to devote himself
to the tranquil joys of family life.

cannot control these tendencies; if she cannot, on the one hand, guard herself against a habitual tendency to exaggerate without, on the other hand, returning to worn-out formulas, her burgeoning originality will be thoroughly destroyed.

This is the case for the exterior of American domestic architecture.

The situation is altogether different when it comes to the interior of American houses. Instead of relying upon more or less appropriate modification of borrowed elements, created for bygone eras, foreign climates, and customs faded into oblivion, everything here corresponds to contemporary needs and immediate requirements. Some of these interiors are like nothing ever before seen, and in fact, are the reverse of the early type of American house, long familiar to us.

In the latter, as one entered, a very narrow staircase led to the bedrooms on the upper floor. This staircase took up half the width of a narrow corridor, the remainder of which led to the three ground-floor rooms; the living room, lit from the street, the dining room which faced the rear, with both of these linked by a third room, illuminated by light diffused from the other two rooms.

From this rudimentary lodging, the American leaped, as is his habit, directly into discoveries of unimaginable sophistication.

The visitor to one of these beautiful houses first enters the foyer, whose walls prepare us for the wonders within, thanks to the exquisite choice of materials and marvelous richness of color

37. Louis C. Tiffany, Fireplace in the Studio of
Tiffany Mansion, 1885.
From Desmond and Croly, *Stately Homes in America*,
1903.

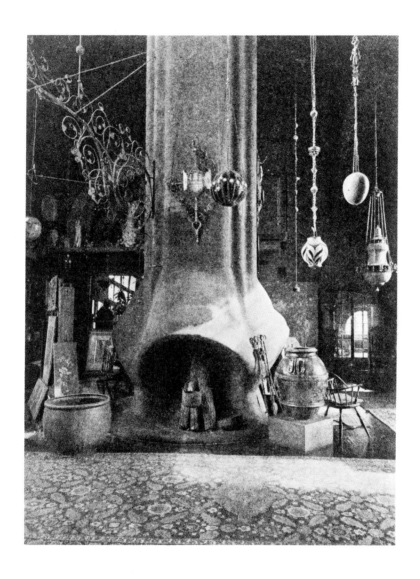

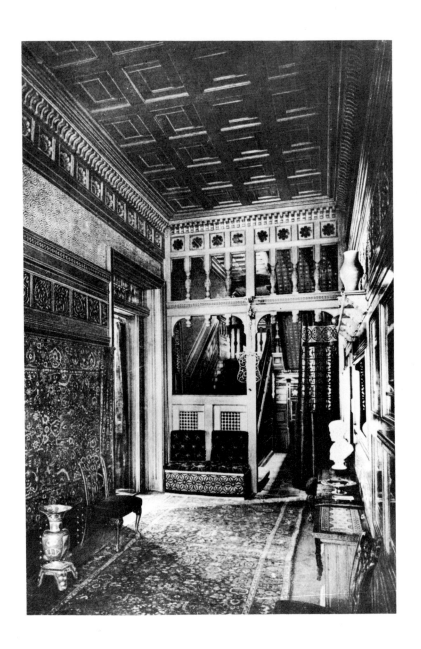

38. Louis C. Tiffany and Associated Artists,
Entry Hall of George Kemp's Residence,
720 Fifth Avenue, New York City, 1879.
From Sheldon, *Artistic Houses*, 1883.

covering them. This entranceway leads into a main hall that links the different parts of the house. While large and light, this room is in no way cold or impersonal, as it is decorated with mosaic ornament in subdued but varied colors. From the moment the visitor enters this harmonious room, he feels caressed by that intimate atmosphere whose charm comes from lived-in surroundings. No other part of the house surpasses this room, and the other sections are grouped around it in so felicitous a manner, that it is a joy to proceed through the vast ensemble. No interior doors encumber circulation. Large archways, artistically draped, lead from one room to another.[10] And since everything in the main hall contributes to the decorative effect, the staircase itself, faced with mosaic, becomes, with its winding steps and richly carved balustrade, the principal architectural motif and most splendid decorative mass.

A similar effect is repeated on the floor above, where this distinctive stairwell widens, opening to a vast sitting room, an ideal landing—simultaneously functioning as music room, art gallery, and social gathering place distinguished by its festive air of gleaming opulence—from which the staircase once again departs, this time forking off into delicate branches, until we finally see it, stripped of all supporting masonry, suspended from the topmost ceiling by elegant shafts or graceful chains sparkling with ornaments. On every floor, around this vast space, the same sequence

[10] Central heating, now universally adopted in the United States, makes such arrangements feasible.

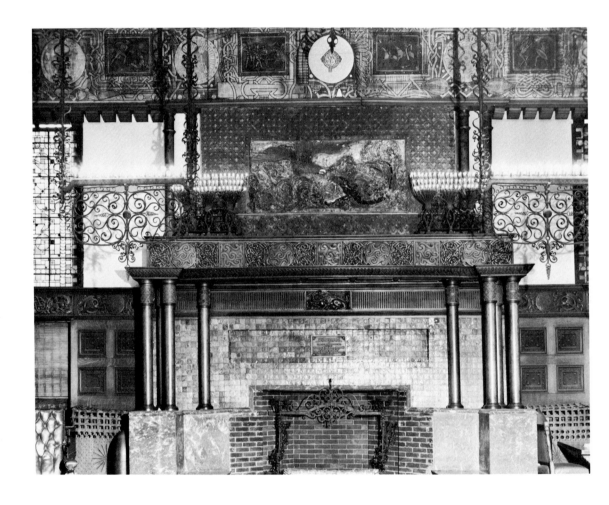

39. Louis C. Tiffany and Associated Artists,
Fireplace in the Veterans' Room, Seventh Regiment Armory,
Park Avenue at 67th Street, New York City, 1880.
Wayne Andrews Photo.

40. Louis C. Tiffany & Co.,
Parlor of J. Taylor Johnston's Home,
No. 8 Fifth Avenue, New York City, 1881.
(Johnston was president of The
Metropolitan Museum of Art from 1870 until 1889.)
From Sheldon, *Artistic Houses*, 1884.

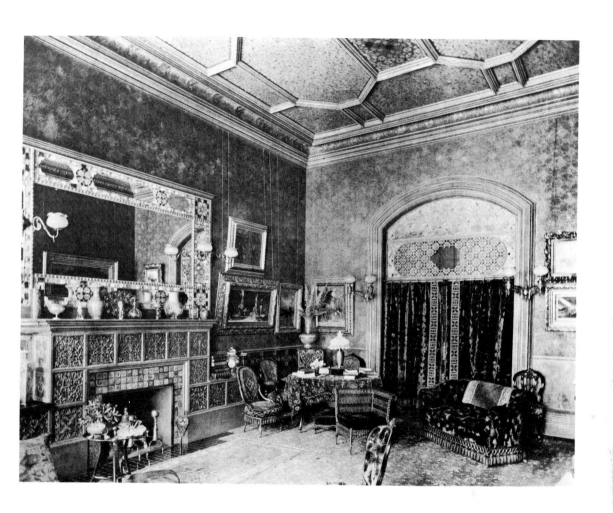

41. Louis C. Tiffany & Co.,
Dining Room of Dr. William T. Lusk's Home at
47 East 34th Street, New York City, 1882.
From Sheldon, *Artistic Houses*, 1884.

of apartments is repeated, in which each master bedroom has its own bathroom, covered in white marble of dazzling splendor.

As might be imagined, no two of these sumptuous interiors are ever alike; the architect's sole concern has been to provide a setting for the individual taste which the future inhabitants will bring to their decor and furnishings. Architect and decorator work in close collaboration, in any case, thus solving the problems that always seem so simple and yet remain so unresolved: the creation of large, homogeneous ensembles.

If urban living must provide a comforting daily refuge, a momentary truce in the incessant struggle to get ahead, and if everything has been geared to this end, it is all the more natural that the country house, conceived to offer still more absolute and lasting serenity to the body and spirit, should further affirm, in every aspect of its organization, this tranquilizing mission.

There were two reasons why America was well grounded in the art of rural housing: her earlier traditions of colonial life prior to the founding of her great cities, and the ever-dominant influence of descendants of the Anglo-Saxon settlers, a race that has always retained a great feeling for country houses. In terms of this kind of architecture, France is far behind. Even among our country houses of some distinction, there are few which express their function in any clear way. With the exception of the great chateaux, succeeded by large numbers of massive houses that seem lifted from the business center of any city, we can point only to shoddily built hovels, completely devoid of comfort, form, or beauty of any kind.

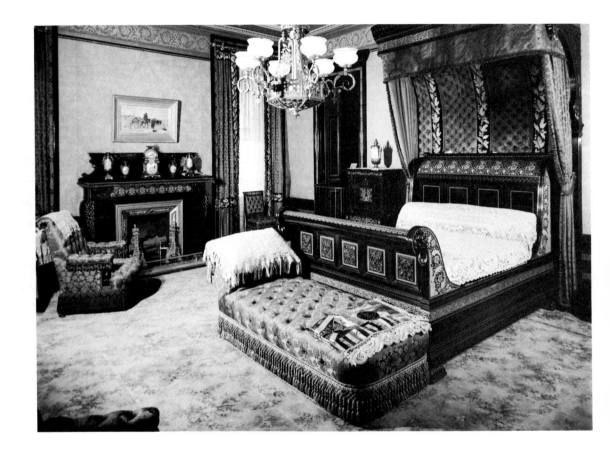

42. Herter Brothers, Bedroom in the
John D. Rockefeller House, 4 West 54th Street,
ca. 1884.
Courtesy of the Museum of the City of New York.

43. Herter Brothers, Dressing Room in the
John D. Rockefeller House, ca. 1884.
Courtesy of the Museum of the City of New York.

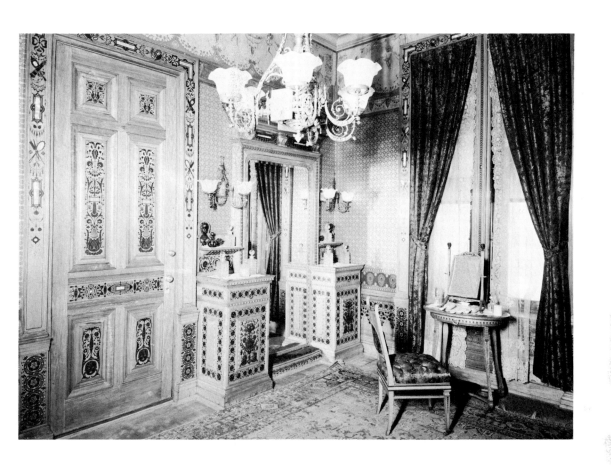

Needless to say, in making such a comparison, we are not thinking of those American summer houses whose overwhelming luxury flourished in famous seaside resorts such as Newport, a place that appears in every traveler's notes. To take such a center of wealth and social prominence as a criterion would be the equivalent of pointing to the elegant villas of Trouville and Biarritz as typical specimens of French country houses. In Newport, the old, ostentatious habits are perpetuated, those dear to the pride of wealth too hastily acquired. But as we have already stated, these pages have for their sole objective the new seeds of the future, those cultivated each day by a small group of like-minded intellectuals.

The latter are enemies of any form of ostentation. Of this there can be no doubt; in a country just beginning to accept art, the lover of beauty for its own sake already exists, to the joy of those whose ideas are in sympathy with his own. It would be illogical to expect to find a sober and virile beauty in things which form part of the whirl of a pompous and frivolous atmosphere. The serious art lover is not only isolated in order to devote himself to an inner life created in his own image; he is more often a solitary person by taste and temperament. Further, his personality requires the open setting of nature. Thus it is in the heart of the lush countryside, on the summit of hills whose horizon is the woods, the mountains, or the distant sea, in the serenity of deepest wilderness that he must seek his true country house.

In no other area has the American more logically subordinated

form to function. In these serene dwellings there is not only an accord between the parts and the whole; but an equally perfect harmony closely links these to all of their surroundings. Appearing to be part of their environment, these houses seem to melt into surrounding nature, as though they themselves had emerged from the earth; in spite of the most subtle aesthetic touches hidden beneath their rusticity, in spite of a general impression of wellbeing which emanates from their every aspect, each part is so consistent with the over-all tone, that they never overpower, by sharp contrast, even the humblest neighboring cottage.

The American country house is low. Its picturesque impression often stems from certain irregularities, which artfully break the lines of the façades and lend variety to the forms of the roof. Inside we find the gaiety created by light, air, and space in quantity. An ingenious grouping of windows assures a view of the most beautiful or striking aspect of surrounding nature, with calculated efforts to provide the best observation points for sunrises and sunsets. On occasion, refinements have included building the large vaulted porch on the bias so as to arrange a more exciting view on leaving the house.

Finally, the kind of beauty nobly manifest in all of these country houses is one emanating directly from their constituent parts, the beauty inherent in the very essence of things and which belongs to them in a predestined way: this is the beauty of all serene and simple art, beauty within reach of modest resources. The country houses perhaps most likely to please an artistic sensibil-

44. McKim, Mead, and White, William G. Low Residence,
Bristol, Rhode Island, 1887.
Wayne Andrews Photo.

ity are those constructed at least expense. We find charming examples of such houses whose cost is no more than two or three thousand dollars. [11]

And if we agree that the beauty of these country houses is founded upon the art of making principles of embellishment logically serve their function, then this same judgment may be extended to all modern American architecture. As seen everywhere, the vitality of this art is drawn from a firm grasp of the practical laws to which it is subservient. Concern for these laws is instantly apparent in the work of all architects, without exception, no matter what style they choose for their own. And if we further acknowledge that, despite a few vagaries, Richardson stands in the forefront as a powerful innovator whose work will always remain seminal, it is not because he fixed upon the Romanesque in preference to some other style, but rather because he grafted upon this ancient stock an art bursting with new life, an art at once clear and comprehensive, mindful of the ever-increasing requirements of his time, requirements that each day multiply to keep pace with the rapidly expanding developments of science and technology.

[11] A vision in a dream, hidden within a mysteriously lucid mind possessing the gift of prophecy—or a vision of reality, an exceptional reality, revealed to a more receptive gaze than those of ordinary men—an idyllic retreat of this kind, was described more than fifty years ago in the work of Edgar [Allan] Poe (*Tales of the Grotesque and Arabesque*) in a story called *The Landor Cottage*. Another work, similar in spirit, is Poe's *Philosophy of Furnishing*, where we already perceive the first symptoms of that quintessential taste that is now coming of age in contemporary America.

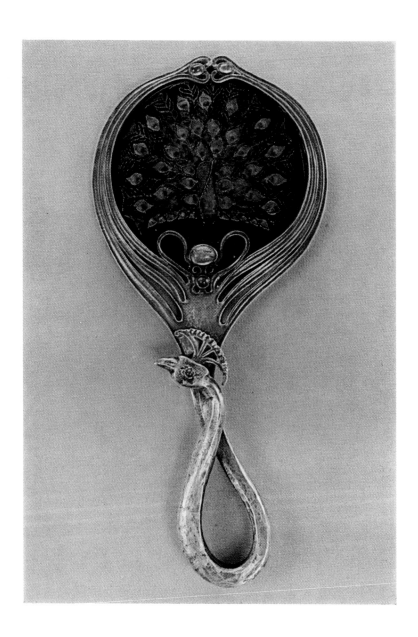

Louis C. Tiffany Hand Mirror, Sterling Silver with
Enamel, Peacock Design.
Courtesy of the Museum of Modern Art,
Joseph Heil Collection.

Industrial Arts

After following the diverse stages in the development of painting and architecture, we should expect to find for the same periods an analogous historical sequence in American decoration or furnishings. But here we would be mistaken.

Painting is an abstract art, requiring only one creator. A painter may emerge spontaneously, in advance of the culture of his time, without being influenced by any external pressure. But conversely, the decorative arts develop only under pressure from pre-existing need, and in favorable surroundings. If the painter's task is limited to giving shape to the content of his imagination, the mission of decorative art is to adapt itself to the taste and habits of others. While architecture must also respond to requirements of a general order, its practice can, nonetheless, predate any diffusion of artistic standards; as American architecture really begins with public buildings, churches, or municipal structures—all belonging to communities whose membership was only too relieved to leave such decisions to the wishes of architects or other higher authorities, and had in any case little experience or judgment in aesthetic matters.

We can easily concede, then, that from the very beginning, painters could immortalize their young country's heroes or render cherished scenes in the surrounding countryside—rare works collected with fervent devotion by a small circle of impassioned amateurs. And we can understand, at the same time, how many cities would have erected a number of buildings long before the

private citizen had come to see the interior of his house as any-
thing more than a family retreat, a peaceful asylum from the harsh
struggle of the market place.

Later, the craving for luxury complicated the earlier traditions
of domestic life. This change was not due to instinct, and still less
to a sudden vision of Beauty; with the privilege of wealth had
come the strong desire for the things which would best reflect it.
The outcome, then, was the absolute triumph of bad taste, and
since America herself was as yet incapable of manufacturing the
desired luxuries, Europe saw opening before her that hallowed era
when she could export across the ocean shoddy wares by the cargo
load, imitations of things that, in themselves, represented the
worst period of our decadent century.

But however puerile may appear the original motive that in-
spired this movement, however disastrous the first steps in a new
direction, the initial idea of decorative experiment had taken root,
to lie dormant until the time when this single seed would bring
forth a refinement of taste.

The time, however, was not yet ripe. And meanwhile, the de-
mand was supplied by French dealers, whose New York show-
rooms multiplied each year. Still, steps were definitely being
made in the direction of progress. It was no longer unusual to
find, in some of the more imposing houses, sitting rooms that
could compare favorably with the banal elegance of dozens of
Parisian establishments.

It was not, however, the area of furnishings or interior decora-

tion in which the first signs of independent taste would be revealed, but rather within the limited framework of small luxury objects, a few precious examples of which have come to France.

Many of those amateurs whose interest extends to all areas of art will still remember their surprise on seeing, at the Exposition of 1878, several examples of metalwork of the most extraordinary quality. Although not intrinsically original in concept—their decorative principles were taken directly from the Japanese—the borrowed elements were so ingeniously transposed to serve their new function as to become the equivalent of new discoveries. In any case, these useful objects were attractive, not least because they had ceased to embody the constant reincarnation of our own traditional forms, however charming, whose interest had long palled with repetition.

This sudden resurgence was due to the clairvoyance of a man whose country should forever enshrine him in grateful memory; Edward C. Moore (born 1827), artistic director of the famous Tiffany & Co., was one of the first to comprehend the real value of the art treasures just emerging from the Orient, and he immediately resolved to make use of the new resources. With great perseverance, Moore accumulated what he felt to be the most representative examples of the decorative arts of Arabia, Persia, India, China, and Japan. This collection, unique of its kind, was left by Moore to the Metropolitan Museum of Art in New York City. Enameled glass and ancient pottery, textiles, brocade and tooled leather, bronze and wrought iron, engravings and water-

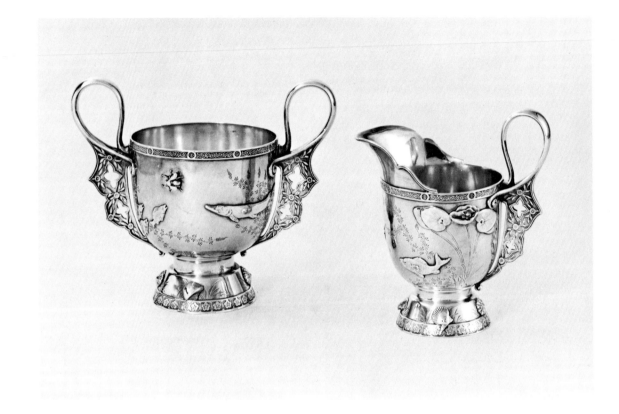

46. Edward C. Moore for Tiffany & Co., Sugar Bowl and
Cream Pitcher of Sterling Silver Inscribed
"MKC April 15th 1880."
Courtesy of The Metropolitan Museum of Art.

colors, wood and ivory sculptures, lacquer and basketwork—
everything, even the most humble object, provided him with the
subject matter for serious study and productive ideas.

Death [in August 1891] put a premature end to Moore's proj-
ect before it could be definitively concluded. But meanwhile,
there had formed around him a small band of younger disciples
who continued the work he had begun, seeking the practical ap-
plication of art in a multiplicity of new forms.

And suddenly, America, which only shortly before had experi-
enced its first artistic stirrings, was to bear proof of singular pow-
ers of initiative and youthful vigor, in sharp contrast with the thin-
ning blood that progressively has weakened the industrial arts
throughout Europe and made impotent our most precious heredi-
tary gifts.

By what surprising phenomenon were the roles reversed? We
French, tireless teachers of all nations, who, for centuries have
continuously sowed throughout the world the seed of our artistic
knowledge, should be especially awed by this sudden flowering
in a barren, far-off land. And it would be still more appropriate
to translate our wonder into discovery of how America can en-
lighten us in our present weakness.

As we proceed to a serious examination of this kind, we should
first recognize that our decorative arts have suffered for too long
from the exclusive prestige accorded to what we pompously call
Fine Art. This truth has already begun to be felt by our artists
themselves. Many have finally stopped considering the products

of industrial art as unworthy of their talents. For the last several years we have observed them happily accept the pariahs of yesterday into their public exhibitions; sometimes the artists themselves have even conceived the design, made ingenious models and molds of every kind, no longer feeling their genius demeaned by working with their own hands, in materials once thought too commonplace. But nothing produced by all of this sincere effort seems clothed in the specific nature of its function; none of it has the really practical appearance imprinted upon objects by real craftsmen. The latter, conversely, when they are experts in a particular technique, and thoroughly familiar with the organic structure of each object, are too much the prisoners of laboriously learned doctrines, with no inspiration in their ideas. Indeed we have our schools of the decorative and industrial arts, invaluable in the training of skilled hands, capable of obtaining every subtlety from the most polished execution. But just as schools of Fine Art fail in their own realm, so schools of Applied Art are unable to galvanize the imagination or ignite a spark of brilliance. For many years, what has been lacking is the artist—of born talent, to be sure—who will commit himself wholeheartedly to an artisan's work.

We sometimes come across a laborer-artist; what we lack is the *artist-laborer.*

Aspiring young artists pursue an unending search for the Ideal; but they can perceive it only in its abstract manifestations; things will be ever thus as long as the world limits its honors to those for whom the supreme dream of Beauty takes certain privileged

forms. Further, as soon as anyone feels vibrate within him bur-
geoning creative gifts, he wonders why he should expend it work-
ing on a thousand anonymous projects, when an inspired brush
or skillful chisel promises the immediate possibility of sudden
deification?

In America, things happen differently. The same democracy
that serves as a basis for the entire social structure of the country
has to the same extent penetrated the world of art. Neither acci-
dent of birth nor choice of one career over another confers any
aristocracy. No caste system could long endure in an environment
where all roads can lead to honor and fame. When an American
artist holds an honored place in public esteem, it is in no way due
to his choice of painting or sculpture; but rather because he has
given shape to a new concept of Beauty—and any tool may have
been used, with equal brilliance, to serve this distinguished cause
—it makes no difference whether it is called brush, chisel, or
something else.

Three men were in the forefront of this movement: Samuel
Colman, John La Farge, Louis C. Tiffany, son of the founder
of Tiffany & Co., and all three had started their careers as
painters. It is safe to assume, however, that their contribution
as painters would have been limited. Their painting is primarily
distinguished for its warm and harmonious coloring, and this
fine tonal harmony would be of inestimable help to them in
their new field of endeavor.

Now, is this to say that the ardent conviction and sound judg-ment of a few original minds must forcibly suffice to change sud-denly a given level of art? And should we assume that if similar initiative were to appear in our own country, it could suddenly revive our talents, dulled for too long?

Indeed no. In America this task has been facilitated, first of all, by the fact that the American mind is not haunted by so many memories. Her youthful imagination can have free rein, and, when it comes to the making of things, her hand is not restricted to a circumscribed number of movements, ever and predictably the same. Not that the American people are anything other than an offshoot of our own earliest roots and, thus, of our traditions as well. What has given them a different destiny is that they do not, as we do, make a *religion* of these same traditions. It is their rare privilege to make use of our aged maturity, adding to it the bursting energy of youth's prime.

From the happy fusion of these two elements, America today has formulated her own theory, as applied to industrial arts, a theory that may be summarized in the following formula.

First, try to enrich the arsenal of usable materials with every element in nature, down to the lowliest, which the blinders of old habits have until now ignored. To manipulate these materials, master every known process and method, in their most diverse applications. Then, after we have learned and analyzed every-thing, acquired every secret technique, every trick of the trade as taught by the experience of centuries . . . then, completely forget the way these have been used in the past, banish from memory

any lingering obsession with inherited forms; in a word, place old and tried knowledge in the service of an entirely new spirit, with no guidelines other than those of intuitive taste and natural laws of logic.

Since this method has already brought forth sufficiently tangible results to augur for its practical value, it should lead to serious reflection on our part. Could we not try, through a virile force of will, to escape the suffocating bonds of past memories? We do not suggest the renunciation of our glorious heritage. Quite the reverse: justifiably proud of our earlier artistic triumphs, we should let their brilliance shine inviolate in the distance of history. If we think about it, we do an injustice to the great influence of these works of art, to their very reason for existence, if we use them as instruments of imitation, in the sole aim of absolving ourselves from the exhausting labor of creation. Why, instead of continuing to reproduce the forms of earlier art, not try to equal the creative genius that gave them birth?

For the last few years, such problems have once again begun to preoccupy our most brilliant thinkers. But for the moment at least, their efforts have not been commensurate with the magnitude of the task. Success in this realm will require something more than witty and imaginative creations, not without quality in their own way, but most often remaining on the level of refined knickknacks, for the exclusive delectation of a few avid collectors. We are well aware of our objective but hesitate over the best way of reaching it.

Let me describe the American method:

Instead of exhausting her strength in sporadic efforts, whose outcome is neither definitive nor conducive to continuity, the American leaders of the new movement act with the same resolve that gives force to every American undertaking. After they have thoroughly planned the projects which they want to introduce, after they have laid the groundwork and decided upon the course to follow, together they consolidate the results of previous random efforts, thus establishing close ties and a real sense of solidarity among the most diverse art forms—major or minor—summoning the most humble individual techniques to join the most lofty concepts. Harmony emanates from these variegated elements focused upon a common goal, unity within complexity. Having achieved this result, we should expect a single style to emerge. But this is not the case, if by style we mean our own habitual aping of previous art forms, these undisguised confessions of impotence; the Americans, to the contrary, are engaged in a search for the subtle and mysterious rhythm which constitutes *style* in the noble sense of the word.

These are the new doctrines; but when it comes to putting them into practice, each artist has his individual way of seeing and proceeds according to his particular abilities and temperament.

Some, like Samuel Colman, limit their role to being theoreticians. In them reside the inventive mind and personality that stimulate others. Using every conceivable object of daily life, Colman popularized the same ideas which Moore had advanced in his metalwork, and like his predecessor, Colman, too,

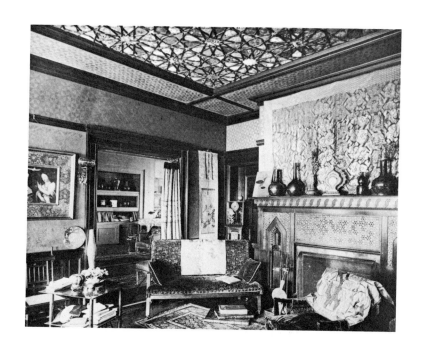

drew upon the Orient. More than any other, he admired Japanese art for its vibrant interpretations of nature and its serene indifference to academic conventions.

Colman was one of the first to promulgate change in modern furnishings, claiming they must be rescued from worn-out forms. He insisted that the Useful need not be synonomous with the Ugly, showing that the Picturesque can be achieved with the most limited space, to emerge unexpectedly in the service of the most modest functions. With impassioned ardor, he preached his point of view to all those who, by virtue of their wealth, were equipped to experiment. His talents as draftsman helped him to convey in eloquent lines the burgeoning forms of his fertile imagination, as his abilities as colorist enabled him to sublime the palette of his distilled tones into charming symphonies. In some of today's homes, art objects of the most far-flung origins are placed side by side, but the ingenious eclecticism responsible for these interiors has so skillfully combined disparate elements, integrating them so artfully, that we are left with an impression of perfect harmony. [1]

Among the promoters of the new movement were those who felt that it was not enough to prescribe certain formulas of their own devising. The spirit of initiative must also be awakened and

[1] In the famous Rembrandt Room of H. O. Havemeyer in New York, the walls, hung with Dutch paintings, are separated from a Japanese ceiling by a frieze based upon Scandinavian designs; the lighting fixtures reveal a Byzantine influence and the furnishings, although obviously reflecting individual taste, suggest the severe forms of our beautiful Louis XIII lines. Yet, in spite of this amalgam, the visitor is struck, from the moment he enters, by the charming atmosphere of calm and repose.

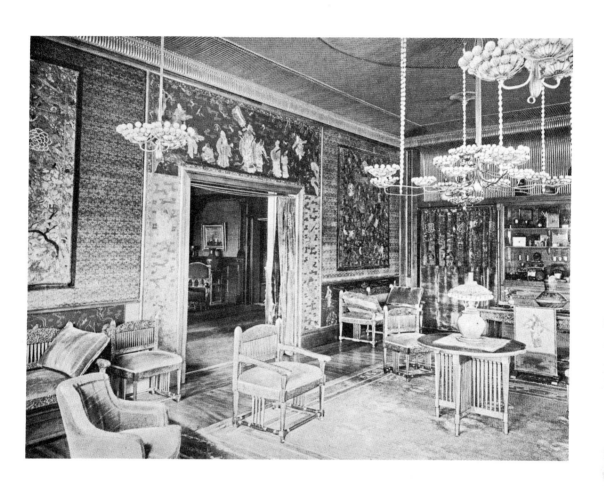

kept alive in the artisan's soul; further, they hoped to obtain the sympathetic participation of a group of collectors and art lovers involved in parallel concerns. But above all, they believed in preaching by example: thus, every project must be launched and followed through personally.

More than any other artist, John La Farge seemed predestined for this militant role. Not content with teaching his original theories in his many impassioned lectures, at which Art and Society mingled, he had, for many years, pledged himself to a highly personal form of action.

Abandoning easel painting to devote himself entirely to decorative art, La Farge waged a long battle against the prejudices of his contemporaries. His work was misunderstood both by the architects to whom he offered his talents as painter, and by the clergy, when the question arose of decorating their churches. It was Richardson alone who, later on, would become a fervent admirer of the brilliant colorist, engaging his talents for the murals and the entire vast decorative scheme of Trinity Church. Lack of assistants and the necessity of completing this enormous job in very little time thwarted the artist's ideal of perfection. On one point, however, public opinion was decisive. All marveled at the large stained-glass window, whose astonishing brilliance surpassed, in its magic, anything of its kind created in modern times.

La Farge had long been concerned with the problem of restoring glass to its former role as an element of decoration. While visiting England, he had seen windows based upon beautiful cartoons by Madox Brown, Rossetti, and Burne-Jones, whose domi-

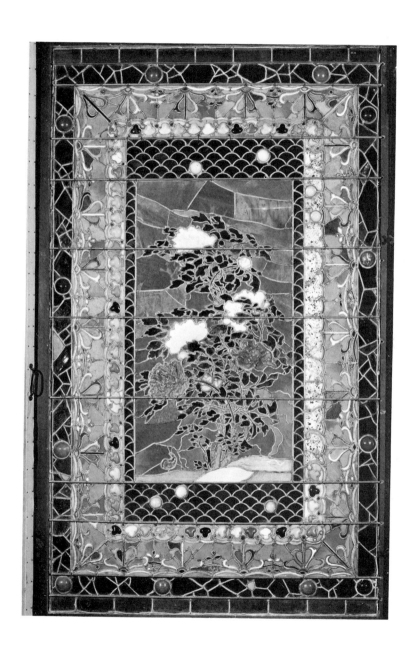

49. John La Farge, Window: *Peonies Blown in the Wind,*
1878–1879.
Courtesy of The Metropolitan Museum of Art,
gift of Susan Dwight Bliss, 1930.

nant principles seemed to conform so closely to his own vision that he made a thorough study of these artists' methods. He subsequently discovered, however, that the works in question suggested a thousand improvements.

While John La Farge was immersed in his studies, Louis C. Tiffany had followed the same path. The most inspiring spirit of emulation existed between these two spirited artists, each encouraging and assisting the efforts of the other.

It was at once apparent, in even the most carefully executed English glass, that the work of the glassblower was not on a par with that of the designer—and each too concerned with his own job to try to unite his efforts with those of the other, in the creation of a homogeneous work of art. But as soon as these stubborn American pioneers saw the virile splendor of an early Gothic window, present-day material was immediately revealed in all its aesthetic poverty, devoid of brilliance or consistency. Unless its appalling harshness and cold transparency of tone—either washed-out or strident—could be remedied, it was inconceivable to think of restoring the noble art of the early glassmakers.

The question then arose whether determination alone was a valid enough reason for reproducing, in our own day, exact replicas of objects whose rationale existed five or six hundred years ago.

Following the guideposts of an earlier road, to summits long since scaled, negates the possibility of going any farther, or of making any new discoveries along the way. Would it at least be

50. Louis C. Tiffany, Water-color Design for a
Landscape Window, Signed on Back.
Collection of Dr. and Mrs. Robert Koch.

possible for new roads to reach equal yet dissimilar heights? In any case, the old secrets of primordial forms of beauty had to be rediscovered; the sumptuousness of material and a whole palette of lost tones; simplicity in the rendering of compositions without the abuse of darkening colors added with a brush. Was that all? Time, the supreme colorist, had also added a marvelous glow to these relics, the ineffable charm, the magic imprint bestowed upon those products of human creation strong enough to survive its rough embrace. Glass corroded by the incessant ravages of centuries makes a thousand capricious flaws sparkle in their jagged outlines. Can any modern equivalent be found for these magical effects? The unconscious actions of nature must be supplemented carefully by scientifically developed effects; and conversely the artifices of a highly sophisticated science must act as substitute for the naïve intuitions of an earlier people.

The task was actually a dual one: the attempt to invent a material equal in quality to beautiful early glass, such as we see it now with the effects of time, with the use of new techniques to create unexpected effects that, although inspired by early principles of forceful simplicity, would come to be identified with our modern vision.

It cannot be claimed that this program was always followed faithfully. As invariably happened, art had to bow to the demands of dubious popular taste in order to save the life of this new industry. But even if the material itself, as it gradually attained unhoped for brilliance, was often exploited in creations of either inferior or bizarre taste, experiments continued.

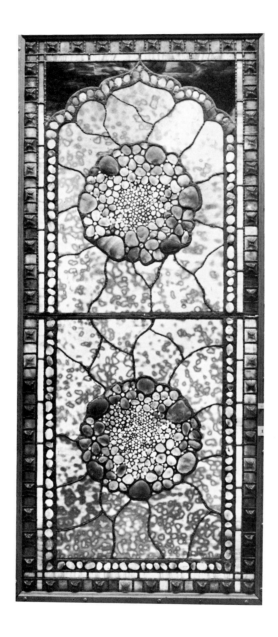

Still other elements were added to the already rich combinations of the new palette. Besides the invention of pearly tones with opaline shimmer, craftsmen worked with mixing natural materials with the tiny bits of glass—transparent pebbles, filtering a mysterious daylight, or precious stones, sparklingly faceted. All of these materials, crushed, carved, polished, mounted, or fitted together, were thus transformed into strange new harmonies undreamed of in the past.

To be sure, these glowing fantasies were not in great demand for the churches, memorial chapels and commemorative monuments whose use is widespread in America. These sacred structures generally feature large, plain windows whose richness must always be allied with sobriety.[2] But the infinite potential of these new resources did open to the art of stained glass a major role in interior design, a role not confined to the decoration of windows. Glass was used to cover walls with mosaics, and sounded its sparkling notes in hundreds of other details of decor.

By happy accident, the revival of stained glass and mosaic coincided with those forms of architecture borrowed from the first centuries of the Middle Ages. The spirit of these two art forms could not have been in closer accord. But what had been a danger

[2] The most famous examples of church windows designed by La Farge are in the Church of the Ascension on Fifth Avenue in New York City. *

* Editor's note: The Church of the Ascension on Fifth Avenue was designed in the Gothic Revival style by Richard Upjohn and built in 1840–41. The chancel was redesigned in 1886 by Stanford White with mosaics by La Farge. The windows were added at later dates individually and include examples by La Farge, D. Maitland Armstrong, Tiffany, and others. The design for the mosaics in the chancel is one of La Farge's best and most famous mosaic paintings.

52. Entrance to the United States Pavilion at the
Paris "Exposition Universelle," 1900, Showing Two Windows
by Tiffany, the *Four Seasons* and the *River of Life*.
From an original photo by V. de Szepessy in the
Koch collection,
gift of J. Jonathan Joseph.

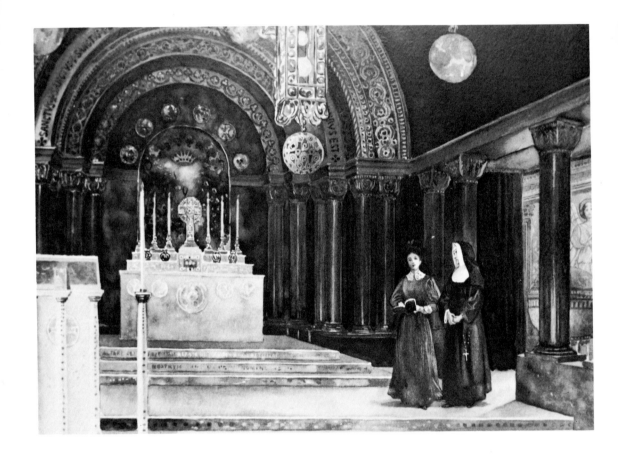

53. Joseph Lauber, Water Color of the Tiffany Chapel at
the Chicago Fair in 1893.
From a facsimile in the McKean collection,
gift of Robert Koch.

for architects was anathema to novices in the decorative arts—the tendency to overdo the assimilation of early techniques. This temptation was most acute in mosaic decoration, whose formula, coaxed from a thousand-year sleep, looks the same today as it must have appeared in the distant periods of its greatest flowering. Louis C. Tiffany discovered how to adopt the lofty character of Byzantine splendor to contemporary taste. He shifted the emphasis from oriental majesty to the soft harmonies appropriate to family living. From the walls of spacious entrance halls, gleamed a rich variety of subtle shadings, sober, chalky whites surmounted by polychromed friezes, diapered with the thousand details of woven cashmere. Elsewhere mosaics covered the walls with a soft warmth, like silken hangings, while on the countermarches of staircases, on ceilings and cornices, mosaic recaptured the richness of its first vibrant glow, as its design and tonalities revealed an unmistakably modern character.

Nor did the role of glass in interior decoration end with mosaic. In the form of cabochons, or other varied motifs, glass appeared in electric lighting fixtures, hanging chains, balustrades—in any place that could provide a rationale for its sparkle, glass, its facets often irregular and unpolished, gleamed in the warmly colored light.

It would have been indeed surprising, in the heat of these tireless experiments, had no thought been given to the transformation of the prime example of a glass object: *the vase.*

In the wake of highly prized, early Venetian glass, with the

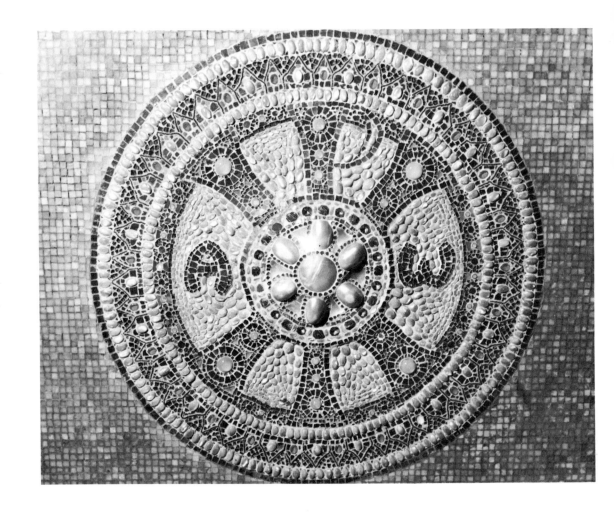

54. Louis C. Tiffany, Detail of the Mosaic of the
Altar of the Chapel of 1893.
Courtesy of Albertus Magnus College.
Chick Hardy Photo.

somewhat exaggerated elegance of its fragile and artificial shapes, after the delicate jewels of the Chinese glassmakers, whose art consisted of carving their strange material like the rarest cameos, after the marvelous creations of our own great artist, Gallé, whose works are the equal, in their unique forms, of nature's most precious stones; after such achievements, what possibilities remained for innovation?

No one envisioned, for a moment, surpassing such triumphs either in painstaking workmanship or brilliance of result. Rather, by moving in the opposite direction, the new designers wanted to return objects to their simplest form, to a point where supreme refinement and scientific achievement would be concealed by the most modest appearance—in forms with all the spontaneity and suppleness of nature itself.

Tiffany, the artist who began to work definitively in this direction, had invented a special kind of glass, very different from the brilliant luminosities of transparent stained glass. His search led to the discreet serenity of semi-opaque tones in which the material simulated fine veins, filaments, and traces of color like the delicate shadings in the skin of fruit, the petal of a flower, or the veins of an autumn leaf. From the artist's hands emerged gourds, the sinuous elegance of stems, half-open calices that, without being slavish copies of nature, took on the astonishing appearance of freely unfolding forms.

Other series of works were the result of experiments of a different kind. Tiffany denied that vitreous substance need always be rigidly linked to the necessity of allowing light to filter through,

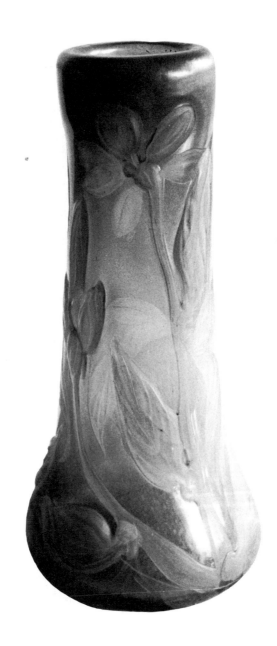

55. Tiffany Vase, Pale Green Opalescent Glass with
Applied Glass and Intaglio Carved Decoration.
Collection of Dr. and Mrs. Robert Koch.

56. Tiffany Jack-in-the-Pulpit Vase, Peacock Blue
Iridescent Glass with a Stretched Edge.
Courtesy of the Corning Museum of Glass,
Corning, New York.

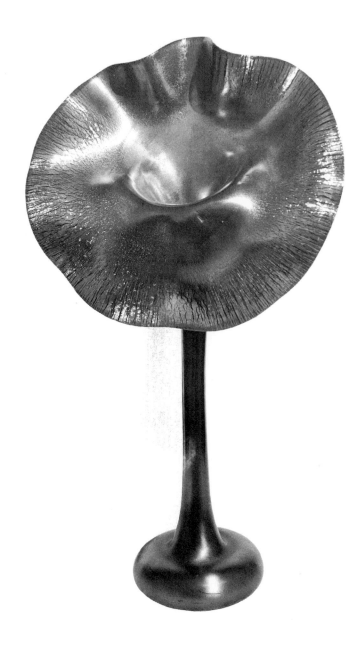

145

on the pretext that the laws of tradition had always willed it thus. He believed that as long as glass did not imitate any other substance, an artist could give new character to his material. Thus, he created a certain type of opaque vase in dull finish, whose beauty—the result of long effort—lay in its incomparable smoothness of surface, as exquisite to the touch as the feel of a delicate silken skin.

While glass was the object of his particular passion, Tiffany was also commissioned to design complete interior installations. In town houses, theaters, gathering places of every kind, chapels large and small, his work is characterized everywhere by the close and homogeneous accord among all decorative elements, whatever their size, between furniture and the most ordinary everyday objects.

Tiffany saw only one means of effecting this perfect union between the various branches of industry: the establishment of a large factory, a vast central workshop that would consolidate under one roof an army of craftsmen representing every relevant technique: glassmakers and stone setters, silversmiths, embroiderers and weavers, casemakers and carvers, gilders, jewelers, cabinetmakers—all working to give shape to the carefully planned concepts of a group of directing artists, themselves united by a common current of ideas.

Through the boldness of such corporate enterprises America may well insure a glorious future to her industrial art. But it

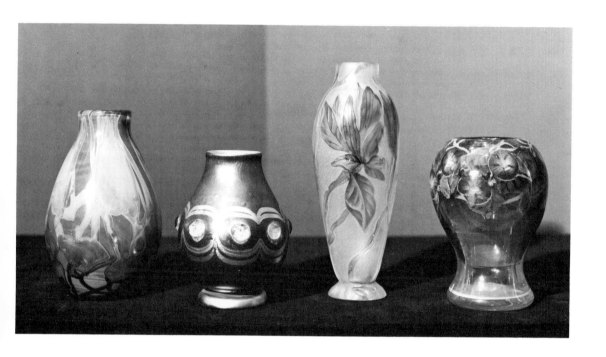

would be an excessive optimism to harbor an absolute confidence in this regard. The path chosen, an excellent one in itself, could easily become a dead end if the nobility of the goal is not constantly kept in mind. The danger is that no single man, least of all an artist, can usually provide, from his own resources, the means necessary for so large an undertaking. Circumstances require, consequently, finding capitalization and founding a large company whose principal concern must be the material prosperity of their business. Above all, orders must keep coming in. However, the time is not yet come when the majority of American art lovers are sufficiently discerning to follow the lead of the few talented artists among them. Unsure of themselves, this great majority copies European examples, which bear the guarantee of long traditions. In spite of a proclaimed disdain for vulgar prejudice, what constitutes Society remains in perpetual thrall to European fashions. And this is especially true of external glitter, when the issue is one of social status and impressing others.[3] For the moment, large companies of this kind cannot survive solely through the patronage of collectors of taste. They are constantly forced by circumstance to submit to the crass demands of local tradition in order to subsist.

In contrast to our own procedures, where efforts have not yet

[3] A name synonymous throughout the world with enormous wealth had commissioned Tiffany to design the décor and furnishings of a formal sitting room to be based upon the artist's ideas. The expenses came to over one hundred thousand dollars. But after the housewarming, when it had been apparent that the break with consecrated rules had horrified the visitors, the whole installation was promptly demolished and replaced by a décor pure Louis XVI.

rallied to the task at hand, Americans feel compelled to go faster than reason dictates. We must all sincerely hope, in the interest of our common cause, that Americans will come to a more balanced understanding of circumstances. For example, it would suffice to start with a few companies, launched on a modest scale, which could, without immediate financial worries, depend upon the limited clientele in whose patronage lies all hope for the future of art in America.

Another point which should be noted is the fact that all of these diverse experiments are in the realm of a sumptuary art which—intelligent or not—is intended only for certain classes of society. Most prosperous families have simply added a larger element of comfort to the simple habits of their ancestors. In this middle class is preserved intact the uncomplicated mentality, the practical and upright nature of the first settlers, whose strength tempered the nation, and whose presence is never more clearly visible than in the habits of domestic life. It was in ever-growing response to the needs of these patriarchal families that American industry made such extraordinary strides forward. Without being contaminated by any self-seeking ambition, its development took place in a rational way, following the improvement in taste and ever-new possibilities of technical resources. In this particular area of art, the manufacturing processes played an important role.

Never before had there been such close association between art and labor. In terms of execution, strictly speaking, art played no role whatsoever. Nor was it even the worker's hand that inter-

vened; with unremitting regularity, the machine did all the work, piece by piece, cutting, grinding, and polishing the thousands of models of exactly identical things . . . But well before this entry into the fray of the mechanical unconscious, art had already completed its own work, giving shape to the task.

The result was an art very different from our own, but an art nonetheless. What we sometimes call "giving everyday objects an artistic appearance" consists of applying to them some form of ornament. This is the system of additions, but additions which add nothing whatsoever to the utility of the object but which almost invariably render them less practical to handle, less harmonious of line, more difficult to maintain; above all, additions which rob them of the real character of their intended use. Furthermore, this intemperate passion for ornament rarely emerges from any spontaneous concept of an original motif, but is almost invariably a travesty of some earlier design, borrowed from things entirely different in nature. In all fairness, it should be added that our own period is not the only one to be at fault in this respect. The Renaissance itself has left us some disastrous examples; furnishings built to resemble vast monuments, where even the smallest utensils, such as tiny saltcellars, were transformed into palaces a few inches high, upon which cornices, entablatures, and caryatides abound. Even the fifteenth century, generally characterized by an art of great clarity, occasionally went similarly astray, particularly in the area of metalwork. The first instincts of a people have always produced a perfect sense of proportion, and we find nowhere greater synthesis of construction than in the products of

primitive peoples; or by chance those found in remote corners of civilized countries where tradition has perpetuated them. *It is always in the name of art that everything is spoiled.*

America, without being a nation any longer in its infancy, has nonetheless been able to seize the essence of a great many things by returning to their original basis, thus spurring our generation to react finally against earlier mistakes. Americans have never understood why a utilitarian object should be embellished with a load of ornament, as opposed to more perfect finish in its workmanship, or the simplicity of a more graceful, practical improvement. The beauty embodied by the appropriate form of things is not imposed through the efforts of reason alone; even when judged purely from an aesthetic point of view, sensibly built objects attract us, so strongly are the laws of logic linked to those of beauty.

Unconsciously perhaps, and through the lucid good sense that is his by nature, the American has put his principles into practice concerning most of the things among which he spends his life. It would be harder to think of any contrast greater than that produced by this nation, when in wildest confusion and thoughtless pursuit of ostentatious luxury, it tries to imitate European styles and when local and specific needs are concerned, proceeds with a precision of plan and objective from which any country in the world could profit.

In those parts of the house reserved for intimate living, the question of hygiene is of first importance. The wall coverings, the wood of the furniture, and all utensils are perfectly plain in de-

sign, and of material smooth enough to display the shine of meticulous cleanliness. Light and air are plentiful everywhere. In all interiors of taste, however simple, perfect harmony exists between the general disposition of the furnishings and the decoration, the architects always bearing in mind both the form of the furnishings and the colors that will best enhance them.

From this principle of identity, which required that each object conform strictly to the practical role assigned it, there emerged a common character, and related appearance, which gradually revealed a kind of local style. If, within these vast workshops that integrate numerous branches of art (such as that of Louis Tiffany) the harmonic fusion of the objects produced is sought with conscious will, the same results may also emerge tacitly from a collaboration of separate efforts. It is primarily the moral ties that draw them together and the close communion of their various characteristics which today distinguish the industrial arts in America, even when seen beside the work of individual talents of whom we shall speak later.

Tiffany is still the first name which comes to mind. But we shall begin with the father, Charles Lewis Tiffany, founder of the great silver company, for which the late E. C. Moore had worked.[4] Another, still older firm of silversmiths, is Gorham and Co. of Providence, Rhode Island, who have the largest factories in America, if not the entire world, employing more than 1200 workers. Besides these two immense companies, there are still others in the

[4] See p. 121.

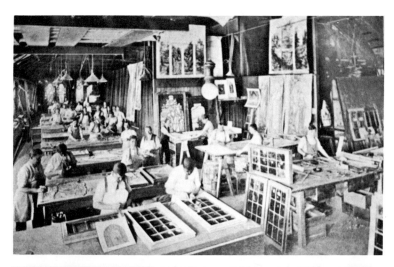

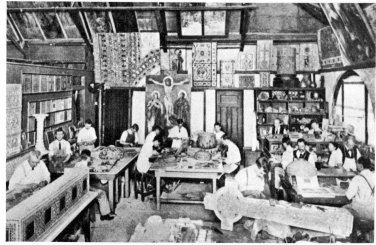

153

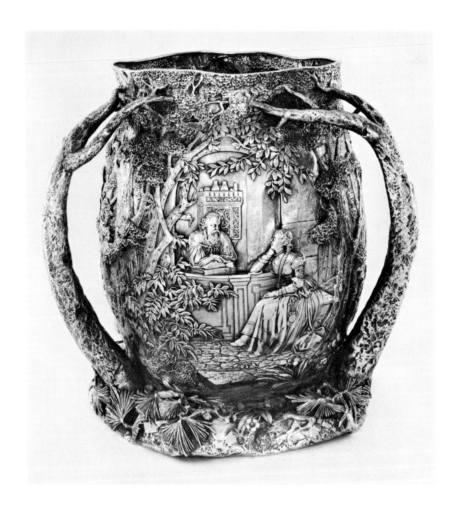

60. Gorham Silver Loving Cup, Presented to Anton Seidl
(Conductor of the Metropolitan Opera)
on February 25, 1887.
Courtesy of the Museum of the City of New York.

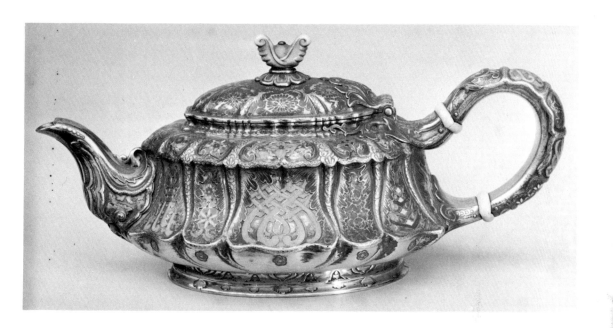

155

same field, such as Whiting of New York, and Spaulding of Chicago.

In any discussion of American silver, one must, as is the case for other industries of this country, separate their production into two entirely separate categories: silver for special presentation and ware for everyday use.

Following the period when Moore had used Japanese models, taste in ornament had declined abysmally. An Eastern style, christened Saracenic, began to cover most surfaces with its tortuous arabesques, and for a certain time, was all the fashion. Then new experiments took place with different processes. Repoussage produced knots of flowers in astonishingly high relief attenuated by chiseling whose fineness was pushed to the furthest possible extreme. Elsewhere were to be seen figurative scenes in low relief, landscapes whose details were more precise than any painting. Well before this period, Japan had yielded her marvelous secret of producing metals in all the colors of the palette. Moore had invited teams of Japanese craftsmen to America, under whose guidance tonalities of every kind were mixed with silver. The effect of these inlays, to which nielli had already been added, was burnished still further by other coloring methods. Experiments with enamels followed, in which, by alternating muted, sombre tones with brilliant, translucent ones, a maximum degree of technical skill and ingenuity was attained. And finally, to be sure that every resource had been exhausted and to obtain the last work in splendor, precious stones were added. For many years, Tiffany & Co. had bought up the most valuable gems available on both con-

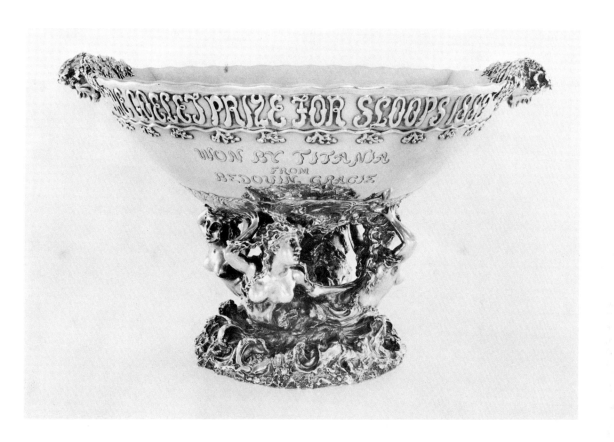

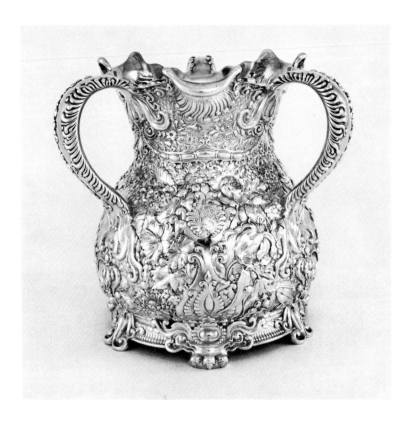

63. Tiffany & Co., Sterling Silver Loving Cup
Presented April 25, 1894.
Courtesy of the Museum of the City of New York,
gift of Harry Harkness Flagler.

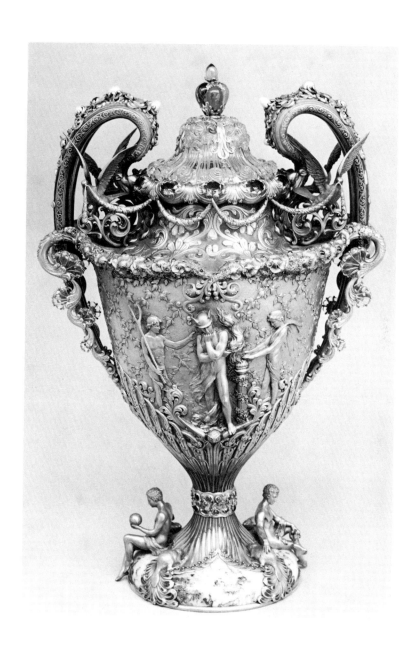

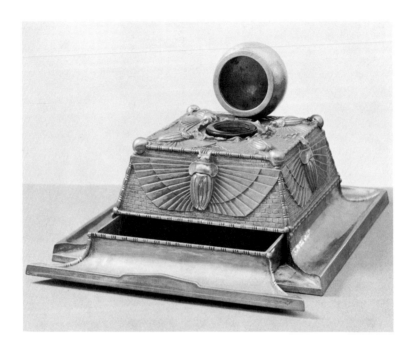

65. Louis C. Tiffany, Bronze and Glass Inkstand.
Courtesy of the Brooklyn Museum.

tinents; uncut stones, which Tiffany then had cut to his own specifications; jewels of every kind purchased from estates; pearls of every form and color; other substances as well, such as ambers of rare color, even tortoiseshell of such kind as provided a special play of light, all of these were combined with other materials, fused in works, each unique, where entirely new effects were created in which the art of the jeweler was wedded to that of the goldsmith. Combinations of still other elements were tried as well. Certain types of ceramic and glass, produced especially for the purpose, contributed their share to the finished product. The role of the last-named material was especially unusual. Once the reticulated metal framework was completed, glass was blown through it in such a way as to emerge in cabochon form.

The highest degree of perfection and the greatest richness of invention from the point of view of technique had been attained. What were the results from the standpoint of Beauty?

In metalwork, as in all American products, every level of quality is found, from the strangest aberrations to the most exquisite creations. As an almost general rule and one which might seem illogical if analogous evidence were not at times apparent in our old European cultures, the most costly objects are those which display the most appalling taste in terms of decorative debauch; this fault becomes most horrifyingly apparent when, instead of trusting original ideas, the aim is to imitate earlier styles. The results may be compared to our stammerings in a foreign tongue, whose grammar is difficult and where the real meaning of the words escapes us. Our own examples of such imitation are usually

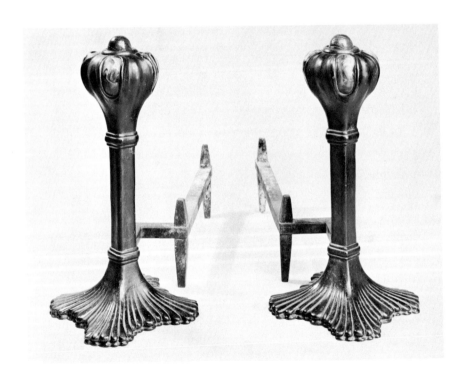

66. Louis C. Tiffany, Bronze and Glass Andirons,
Made for Robert W. De Forest.
Courtesy of The Metropolitan Museum of Art,
gift of Mrs. C. Chester Noyes, 1968.

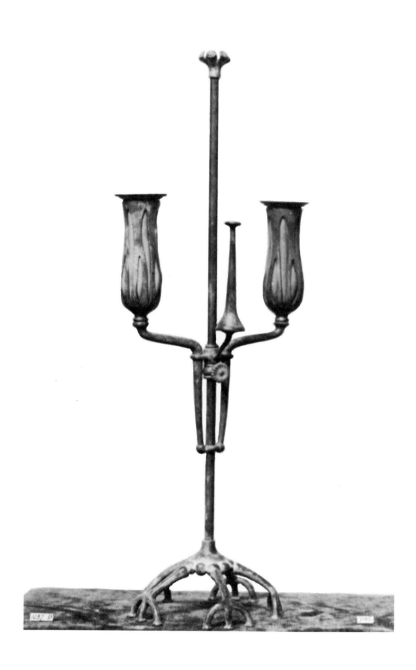

163

saved by certain native qualities of grace and delicacy, but in the
United States they are completely ruined by a leaden pretentious-
ness that corrupts even the most attractive objects.

By contrast as soon as we turn to the familiar domain of objects
of everyday use, the practical American spirit reasserts itself,
outstanding for its felicitous sobriety, a quality encountered far
less frequently in the use of precious metals than in other mate-
rials. In the former area, the artist is involuntarily swept along by
the idea of preciousness inherent in the substance. Thus, the tea
services which feature the most staggering load of ornament may
sell for as much as $20,000. The largest fortunes, those requiring
things of this sort, often exert a deadly influence, so we should
be thankful that not everyone can afford such luxury. In this may
lie the salvation of American art.

Nothing supports this argument more than the simple beauty
of some pieces of silver meant for everyday use. The natural flow
of the lines, dictated by function, is a thousand times more attrac-
tive than any artificial concept. When the logical structure of
form is enhanced by elegant additions, such ornament is based
upon the free-form design of a plant or flower, or upon the teem-
ing animal kingdom. Is it their continuing contact with Japanese
art which has made Americans turn so enthusiastically toward
nature? Is it not rather the fact that this new nation retains certain
primitive learnings? These two factors have doubtless acted in
concert.

Finally, the greatness of this branch of industry in America
again stems from the indomitable energy of the bold men who
created it. From the very first, these pioneers went far beyond the

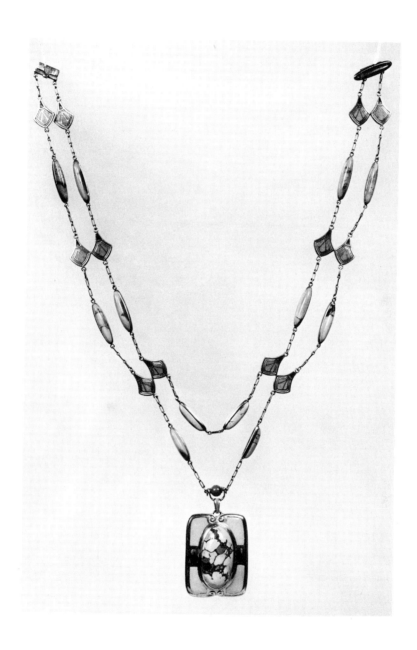

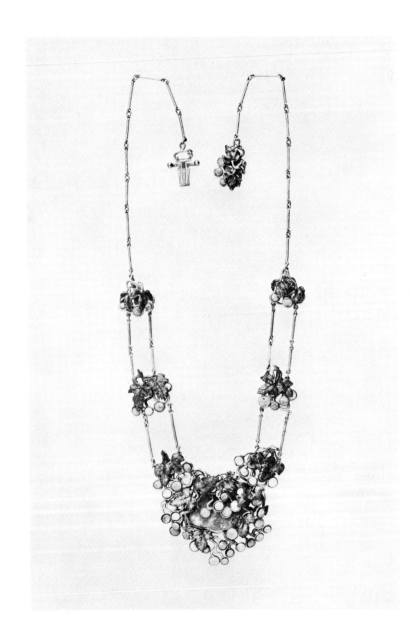

69. Louis C. Tiffany for Tiffany & Co.,
Gold, Opal, and Enamel Necklace,
Exhibited at the Paris Salon of 1906.
Courtesy of The Metropolitan Museum of Art,
gift of Miss Sarah E. Hanley, 1946.

70. Louis C. Tiffany for Tiffany & Co., Peacock Necklace
of Gold and Opal Mosaic Set with Gem Stones,
Exhibited at the Paris Salon of 1906.
Courtesy of Hugh F. McKean.

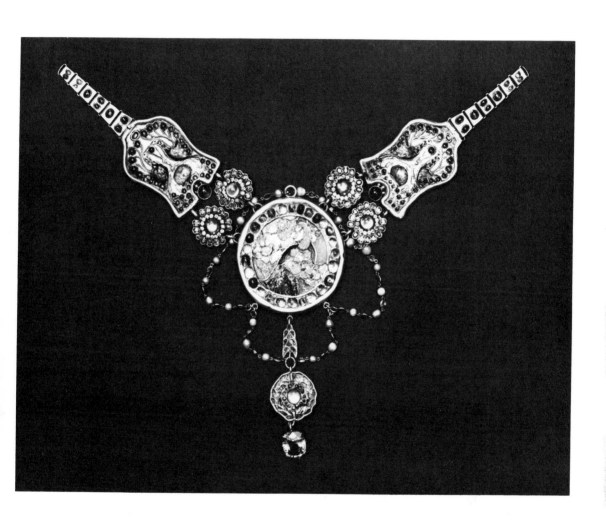

167

most grandiose workshops ever known. To staff their splendid cosmopolitan ateliers they drew recruits from England, France, and Italy, all bringing with them the traditional knowledge and skills of their countries of origin, and who, in turn, trained new generations of craftsmen whose studies were completed through the use of libraries, vast collections of pattern books and museum-sized collections of models installed in the midst of the factories themselves.

But if the foreign artists were expected to divulge all the secrets of their craft, they were rewarded in turn by new American concepts, and above all, powerful equipment of the most incomparable perfection was placed at their disposal. For everyday objects, such as spoons, forks, knives, and other pieces of tableware, a number of models were created, more supple and graceful than any of our earlier designs—and much more practical—each utensil especially designed for a particular course. Because of their great simplicity of line, all of these were marvelously well adapted —once the original model had been developed—to being mass-produced in infinite number through mechanical devices of recent invention to provide, at moderate prices, products of irreproachable quality.

Among the foreign artists who had successfully worked in American silver, the most numerous, and by far the most talented, came from France. But it is not this industry alone which the French have helped to establish in America. When one investigates the field of American industrial design, one finds significant traces of our national genius at its base.

Many French glassmakers who had discovered the art of making glass plaques with uneven surfaces and iridescent colors, having seen their discoveries ignored in their own country, came to the United States, where fifteen years ago they settled in Brooklyn, a small suburb near New York and were there introduced to John La Farge and Louis Tiffany. Seeing their talents recognized, they provided invaluable assistance to these two impatient experimenters in all of their productions.[5]

This industry soon entered an incredible period of expansion. The small city of Kokomo, Indiana, which profits from natural gas, now boasts several factories engaged in the production of stained glass, one of which is managed by a Frenchman, M. Henri.

This kind of factory provides the material for most of the companies producing stained-glass windows, among whom—aside from Tiffany and La Farge discussed at length earlier—are other well-known companies, such as *William Heith* of Philadelphia, *Cully and Miles*, and *Healy and Millet* (the latter of French descent), both in Chicago. There is scarcely a respectable house today whose entrance does not boast a stained-glass overdoor. Further, this colored glass is frequently seen filling the curve of the archways between two sitting rooms (interior doors hardly exist in American houses). Without for the most part aspiring to the title of works of art, these transparent partitions of gaily re-

[5] Among those pioneers we should mention M. Heidt, still active, as well as Messrs. Bournique and Contat, formerly with Baccarat, both now dead. For this information I am indebted to M. Gaudin.

flected light usually consist of pretty ornamental drawings, a decoration in the best possible taste.

Another flourishing decorative industry today is the manufacture of wallpaper. A large number of factories—New York and Pennsylvania alone boast more than twenty—produce excellent work, essentially modern in taste, whose designs, free in form and brightly colored, are equal in quality to English products and could provide a salutary example to our French manufacturers. (Alas, where is the time when Paris was the world leader in the production of wallpaper?)

Finally, we should mention certain industries, still in their earliest stages, which hold promise for the future.

Wrought iron would seem to have great prospects in store under the auspices of *Yale and Towne Manufacturing Company* and those of *Winslow Brothers* of Chicago. The products of these two factories are of impeccable workmanship, of pure and independent taste, and manifest the most serious striving for quality.

In the realm of *ceramics,* experiments of very diverse quality have appeared—still timid for the most part. Only the Rookwood Pottery Company of Cincinnati has gone boldly ahead in new artistic directions. Its products, using the technique of colored enamels, are closely akin to similar experiments which have been carried out in France over the last few years. Actually, both sides of the Atlantic use the beautiful Japanese stoneware as a model. It may well be that in this area, so remote in origin, America will rapidly overtake us, given her energetic methods of tackling every problem. The Rookwood Company unhesitatingly hired

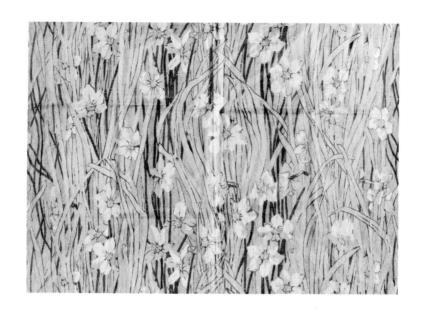

71. Candace Wheeler for Cheney Bros.,
Linen Printed with Narcissus Design in White and Green,
ca. 1885.
Courtesy of The Metropolitan Museum of Art,
gift of Mrs. Boudinot Keith, 1928.

72. Louis C. Tiffany for Warren, Fuller and Co.,
Wallpaper Design, 1880.
From Cook, *What Shall We Do With Our Walls?*

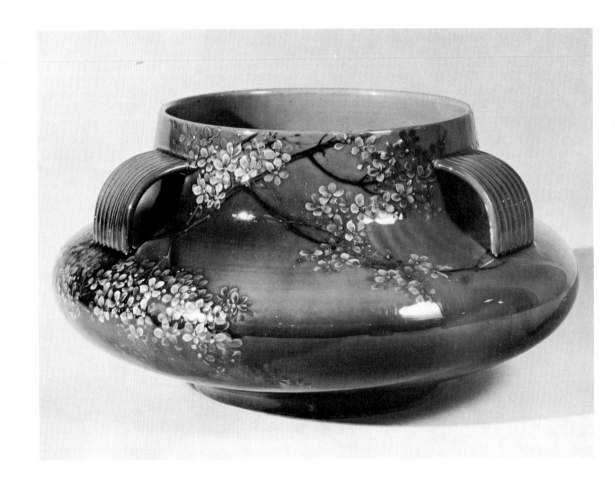

74. Rookwood Pottery Japanese Flower Bowl,
Decorated by Laura Fry, 1890.
Courtesy of The Metropolitan Museum of Art,
Edgar J. Kaufmann Charitable Foundation Fund, 1969.

75. Rookwood Pottery "Uranus" Vase, 1900,
with Medals Won by the Pottery.
Courtesy of the Rookwood Pottery.

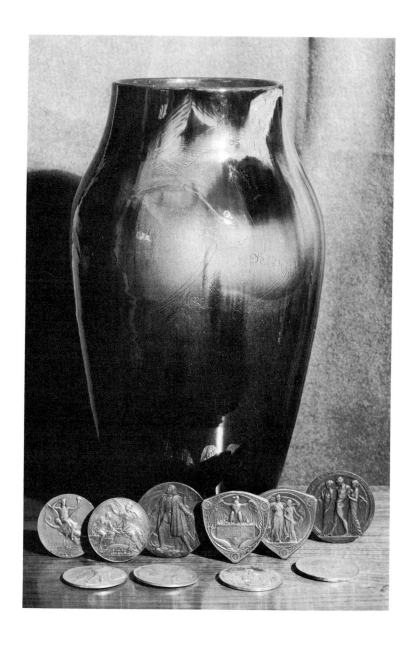

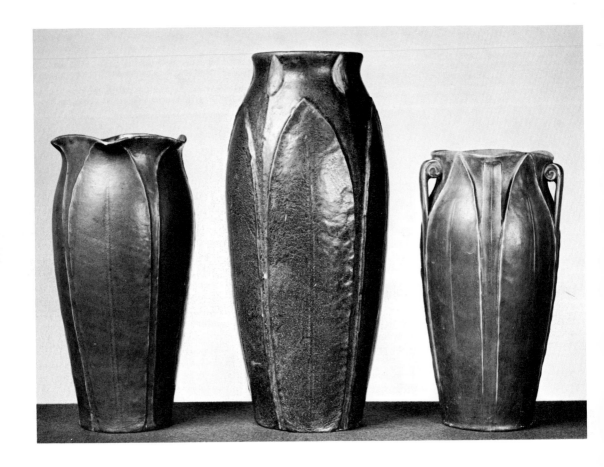

76. Three Grueby Pottery Vases, ca. 1900.
Courtesy of the late John Pierce.

Japanese artists as instructors, thus avoiding many mistakes.

How much more worthy, to be sure, are the painstaking, individual labors of our fine French artisans in their agonizing struggles against the unpredictable caprice of fire, and who have, as their only weapons, their inmost intuition of Beauty, their tenacity and passionate faith. In them we see the atavistic traces of our great artists of the past, whose concentrated passion seems out of place in our own practical century. Everything has changed. For progress in the years to come, it is results, alas, not feelings, which count. The future belongs to those who can foresee it and whose only fear is delay.

Along similar lines, another industry sums up, in an eloquent symbol, the rapid passing of time, the abrupt substitution of new conditions for outdated ways of doing things: this is the modern lighting industry.

What do we see in America? As soon as the problem of electric light production was resolved, it was understood that a new era had begun which would completely and utterly change all the conditions of present lighting, to open the way to unforeseen applications of the new device. Instead of struggling, as we do in France, to attach the early beginnings of the future to the relics of the past, American genius, faced with this barely conquered force, discerned not only the scope of its future role but had a clear vision of the particular forms into which it should be incorporated. Instead of limiting the new method of lighting to the illusory use of traditional fixtures, the Americans immediately did away with all the old systems that had been created for other kinds of light.

An entire arsenal of new machinery, in all its multiple applications was thus calculated with a view toward the special conditions of the new element. For this weightless substance, no more ponderous lamps, whose only rationale had been to contain combustible liquid; no more rigid, unattractive tubes to serve as gas ducts, no more complicated lusters, whose cumbersome mass denied the very idea of the evanescent light suggested by electricity.

For the first time in history, a system of lighting had been discovered which imposed no restrictions upon the invention of form. This extraordinary opportunity suddenly offered to the creative imagination was grasped immediately by America as a possibility to enhance further the sumptuousness of interior décor, and to ensure that design would benefit from discoveries of practical application.

Its special properties made it possible for electricity to be used in the most whimsical arrangements. Its light, so intense in its naked state, was sometimes shaded into an opalescent glow, at other times diffused into brilliant beams refracted by the hundred prisms of multicolored glass. In this kind of fixture, glass, revealing its most magical effects, takes on the role of a marvelous collaborator: in hanging lamps whose invisible source of light is diffused through colored foliage, mounted in silver, and suspended from luminous chains; in banks of lights hidden behind screens dropped from the ceiling—pompous jewels of translucent glass mosaics, whose fiery tones shine intensely on wall surfaces hung with paintings; luminous pistils emerging from stylized garlands, whose sinuous architecture runs the full length of cornices;

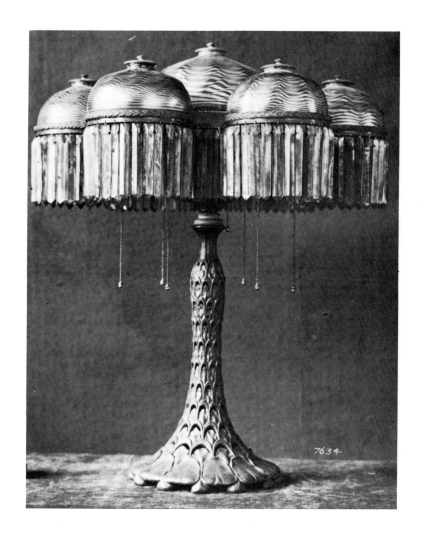

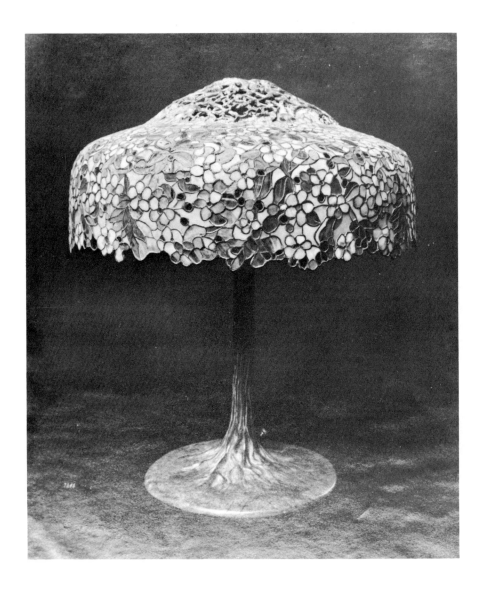

78. Louis C. Tiffany, Apple Blossom Lamp of
Bronze and Coppered Glass.
Tiffany Studios photo, courtesy of Mary Tuck.

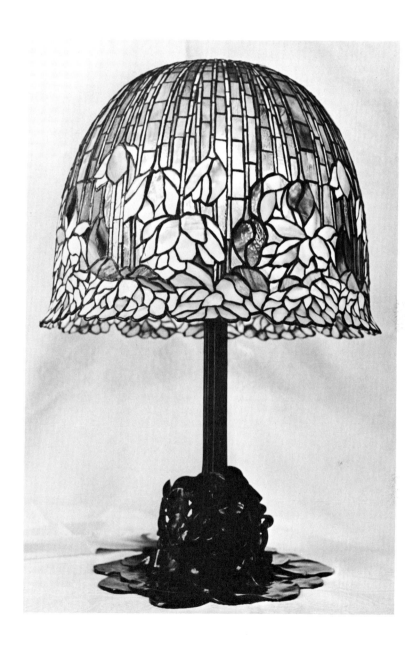

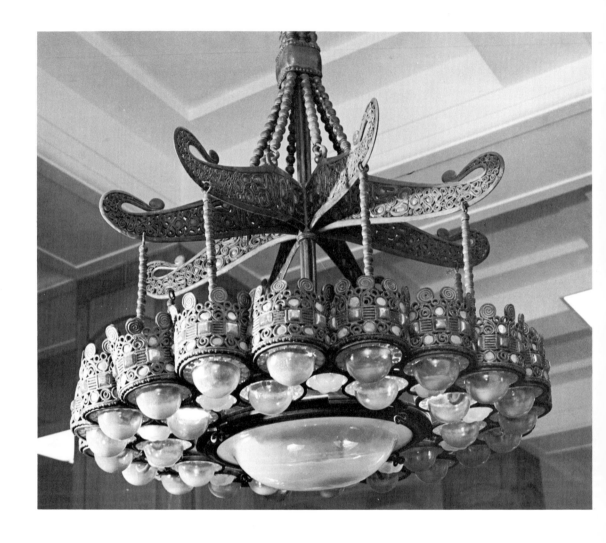

80. Louis C. Tiffany, Lighting Fixture of
Bronze and Glass Set with Stones, 1892.
Courtesy of the University of Michigan.

and a thousand other motifs of similar kind combined with architectural details—imbedded in the walls surrounding doors to corridors, hidden behind the corner of an apartment wall, rising in relief around mirrors above fireplaces, gleaming from capitals of columns, and always so designed as to disperse a soft, even light, while unlit in daytime, they still consitute ornaments in perfect harmony with their surroundings. Sometimes, in a particularly lavish interior, the mysterious gleam of a luminous wall emerges from the shadows, magical in its harmonies, and whose appearance, stimulating the imagination, transports it to enchanted dreams.

Conceived in a very different spirit are the fixtures for daily use of the general public. Never has the taste for cheap luxury been indulged with quite such banality, as in the fondness—all too widespread on this side of the Atlantic—for pretentious, shoddy work that parodies creations of a superior order. What is required of this kind of apparatus is solid workmanship, geared to its utilitarian function, easy and agreeable to handle. Through conscious elimination of self-indulgent ornament, the line becomes simplified, gaining in suppleness, attractive to look at, and further, providing the means of economical reproduction.

One axiom has it that the machine is the predestined enemy of art. The hour has finally come to discredit such ready-made ideas. The machine can propagate beautiful designs, intelligently thought-out and logically conditioned to facilitate multiplication. It will become an important factor in raising the level of public taste. Through the machine, a unique concept can, when sufficiently inspired, popularize endlessly the joy of pure form, while

preventing the distribution of a multitude of inept creations whose sole claim to being works of art stems from the presumable difficulty or skill involved in making them by hand.

It cannot be said, however, that America was guided by this kind of reasoning when she put these doctrines into practice. Rather, it was through the hidden force of existing circumstances that mechanization took place in the United States, through a sort of inherent intimacy with her own latent needs, needs for which new industries had to provide equally new methods.

But if this same demonstration was nowhere as conclusive as in the lighting industry, culminating in the above-mentioned results, it is equally true that all of the industrial arts developed more or less along the same lines, all profited from having appeared at just that period when the conditions of life took on an unexpected aspect, thus formulating new requirements with which they could cope without being shackled by a multitude of time-honored customs. Every day we encumber our ancient intellectual structure with all sorts of additions; *by using every modern discovery, the New World can build its own structure with a single effort.*

And if, in the impassioned fervor of this work, errors are made constantly while we look on with a skeptical smile, let us be careful. We should be fully aware that these mistakes stem from the naïve inexperience of a youthful people in the full force of their power, and whose every try, even those which miss the mark, is made with all possible strength. Which is why when America is wrong, she is never wrong by halves.

If, in the same field of industrial design, we analyze instead the excellence of the results obtained, we can distinguish the following prevalent conditions:

The complete and total rehabilitation of that category of art which, renouncing the glories long restricted to painting and lofty sculpture, is concerned with enhancing the prestige of everyday objects, those whose perfection is a thousand times more important than any other.

The establishment of huge factories to concentrate the most diverse branches of decorative art in a search for a determined goal, prescribed by the powerful will of a single directing spirit.

A moral bond and tacit collaboration uniting scattered efforts; taking a multitude of external forms, identical tendencies, unthwarted by unreliable recollections of a past centuries old, and adapted to the particular conditions of time and place.

The strict subordination of questions of ornament to those of organic structure; the inner conviction that every useful object should draw its beauty from the rhythmic ordering of lines, which, before all other considerations, is subject to the practical function to be fulfilled.

The enthusiastic adoption, even at enormous financial sacrifice, of the most advanced methods; the organization of model factories and workshops, a constant readiness to relinquish old machinery as soon as new, improved models are available. In a word, the rule is: be ever and always equal to the perpetual metamorphoses of the times, the day and the present hour—in every branch of human activity ripe for development.

Summary

America, du hast es besser (America, you're better off
als unser Kontinent, das alte than are our own old nations,
hast keine verfallene Schlösser You have no ruined castles
und keine Basalte. and no rock formations.
Dich stort nicht im Innern, Untroubled are your soul and mind,
Zu lebendiger Zeit, in modern times alive
unnützes Erinnern by vain and useless memories,
und vergeblicher Streit. by idle, fruitless strife.) *

Goethe, *Zahme Xenien*, Vol. IX (*Nachlass*)

These significant words, quoted by Professor Lessing in his knowledgeable description of Chicago, were not written today. Indeed, they resound like the distant echo of an oracle, for they were uttered by Goethe's penetrating genius more than sixty years ago. However, we can no more take them at face value than the former mysterious pronouncements of the ancients. America is not, to be sure, exempt from all kinds of memories. But those inherited from her ancestors do not usually manifest themselves in any intense fashion, and when they do, it is almost always in a way particular to Americans.

Of all the arts, painting was the one in which traditions carried to this country by the first settlers were perpetuated in lively, yet

* For the identification and verse translation of the poem, the translator is indebted to Professor Peter H. von Blanckenhagen.

faithful fashion.[1] Painters were active at a very early date when the ties that bound the young nation to European culture were still very strong. Americans had not yet had the time to become a new people with a distinctive way of life. Thus, there were few links missing from the age-old chain that bound American painting to our own art.

This is the only reason for that total absence of local flavor or stamp so striking in American art, and which forever condemns it to remain an art of reflection, often lacking, on the whole, force and sincerity.

American art began by adopting the portrait, borrowed from the English School—to be followed by other genres: history painting, classical, mythological, and modern, varied in subject matter, which imitated in turn the styles of every country and every period. Occasionally, a few ephemeral glimmers of independence could be discerned, only to flicker into banality. Finally, nearing the present, a large important school of landscape painting emerged, highly individual in character, and in particular, distinguished by warm and harmonious color. In the realm of genre painting, on the other hand, the level sinks to the most tasteless trivia, devoid of any feeling for color or beauty of idea, until, at last, American painting was to be carried along by the sweeping current of our modern French schools of painting, when, in the final instance, we see the emergence of a few superbly talented

[1] We except *sculpture*, which, as we have seen, is too recent an art form in America to have managed to dissociate itself from European models which it completely imitates.

artists, with highly personal styles. Throughout these diverse phases, American painting has remained the single great form of expression that (unlike the painting of other nations) does not provide us with a detailed revelation of national life, customs, and appearance of the inhabitants, or the distinctive characteristics of the people.

American painting today stands on the threshold of a richly flourishing era, when it may well lend noble assistance to the cultivation of this old domain, the legacy of centuries; but for having assimilated this heritage too thoroughly, American artists will have difficulty pointing the way to new horizons, and in staking claims to new territory in the name of the universal empire of art.

The situation is entirely different when it comes to architecture and above all the industrial arts.

Here, once again, it will seem obvious that the New World could not improvise completely new elements heretofore unknown. In more or less conscious fashion, America took something from every civilization, but this was done very judiciously, by taking earlier creations apart piece by piece, changing them, then adding something of her own by returning to the study of nature, and using the contributions of ultramodern forms of science. As these strange combinations assumed a profound unity of character, they became the point of departure for a new aesthetic, one attuned to local conditions, determined in time, and imbued with the spirit of the people.

If American architecture, after the modest beginnings of the Colonial style, after the more or less transient fashions of Greek, Gothic, and Renaissance forms, chose as early a prototype as Romanesque, deriving from it a kind of modern American style, it was not, in spite of the apparent paradox, without good reason. The gravity with which American religion goes about its rituals made the formal austerity of Romanesque eminently suitable for its churches, while commercial architecture found that the same idiom of imposing mass was the perfect incarnation of the power of big business; finally, for a domestic architecture whose object was to shelter family life warmly and comfortably, the same external severity of appearance was still justified with no less logic.

Decorative Arts, while conforming just as rigorously to contemporary requirements, had a far wider role in store and disposed of a much more fertile field with which to transform the precious riches of past knowledge. Even if the very first efforts were enthralled by Japanese models, the American people, when confronted by an art created for such entirely different traditions, were too shrewd to see it as anything more than a charming decorative accessory, a welcome addition of grace and freshness to the uniformity of their surroundings. Of all the early art forms, those which seemed most appropriate to the spirit of the country were found in Byzantine art, in the first periods of the Middle Ages, in Arabic art—in any art where amplitude of line, at once picturesque and simple, was enhanced by coloring that was sumptuous without being violent. These are really the dominant qualities emerging from recent American experiments, from the new

American ideal, in which artistic forces of the past, instead of remaining elements of a naïve archaeology, are modified in response to present-day requirements, by a thousand different transformations and their ingenious fusion with modern concepts.

We bear as our heritage an ancient patrimony, the result of twenty civilizations; we are fortified by long experience nurtured by all the phases of a long development; we possess faculties of sensation rendered more acute each day—a vital bloodstream that, in spite of periods of sluggishness, is capable of being at any moment quickened by new infusions of creativity.

America, a later arrival, is aware of the power at her disposal, a power that attempted to encompass in one burst of strength the progress which other peoples have taken centuries to make. Starting out with small preparation for the conquest of every intellectual domain, she has, on many occasions, lost her way, blundering into baroque schemes, foundering in a thousand extravagances. But is not this only the enviable presumption of impatient youth, an impatience rapidly tempered in practical experience, in the serenity of leisurely studies and, still more, in the vigorous common sense with which the American people have been blessed by nature?

In the past, like a *parvenu* frantic to enjoy his recently acquired wealth, the American people, elated by the results of their efforts, felt they had achieved the supreme goal. But the passage of time has sobered this kind of intoxication; new generations have brought new aspirations. At this very moment, a new era

dawns. At the very heart of a pompous empire of money an intellectual aristocracy has evolved which will move far and fast. The time is not far off when, in her midst, poverty of aesthetic feeling will be greater cause for shame than any form of material want.

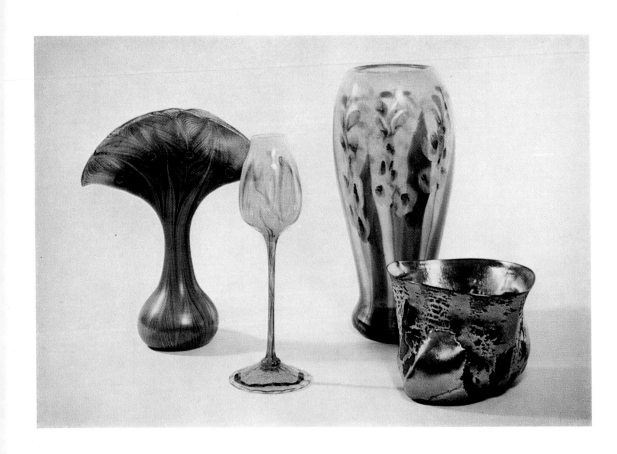

Three Tiffany Glass Vases and One Tiffany Glass Bowl
in the collection of The Metropolitan Museum of Art.
Peacock and Flower-form Vases, gift of H. O. Havemeyer,
1896; Lava Bowl and Gladioli Vase, gift of
Louis Comfort Tiffany Foundation, 1951.

II
Louis C. Tiffany's
Coloured Glass Work
S. Bing

Louis C. Tiffany is the son of the celebrated New York jeweller and goldsmith, Charles Tiffany, who for more than twenty years has enjoyed a world-wide reputation. Of an idealistic temperament, the young man at first devoted his youthful ardour to the study of painting. The refined feeling which that art instils into its votaries was, with him, displayed in a passionate enthusiasm for colour—rich and luminous colour. His acute sense of, and appreciation for, harmonious tints was a natural gift, but it strengthened gradually with use, and was perfected to a supreme degree during his long voyages in the East; and so Tiffany was inevitably led to exercise his creative talents in a less restricted field than painting, in a more fruitful province long unrecognised—the Decorative Arts.

What impressed the young artist and filled his heart with a transport of emotion never felt before, was the sight of the Byzantine basilicas, with their dazzling mosaics, wherein were synthesised all the essential laws and all the imaginable possibilities of the great art of decoration. Exploring the depths of a far-distant and glorious past with the aid of these venerable monuments,. Tiffany dreamed a dream of Art for the Future: in the fossilised remains of our ancient patrimony were revealed to him the primordial principles that live for all time. In thus evoking the souvenirs of bygone ages, the danger was that he might arrest the flow of the bold and spontaneous conceptions which are the

This article was published in German as "Die kunstgläser von Louis C. Tiffany" in *Kunst und Kunsthandwerk*, Volume I, 1898 pp. 105–111. In English it served as introduction to an exhibition at The Grafton Galleries in London in 1899.

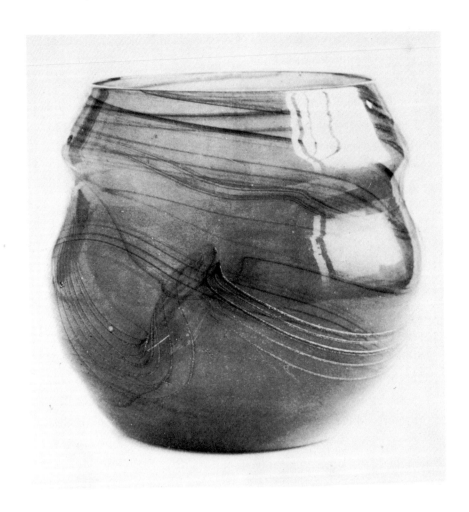

81. Tiffany Glass Vase Purchased from
Samuel Bing on July 1, 1894,
by the Musée des Arts Décoratifs in Paris.
Courtesy of the Musée des Arts Décoratifs.

strength of the innovator. How many partisans of a resurrection of the Decorative Arts had made shipwreck in that way! But it has been given to the youthful American race to profit by our old traditions in a more broad-minded spirit, while at the same time preserving the transatlantic love of independence. Moreover, America has always been distinguished for its capacity to bring its enterprises into perfect keeping with one another, and to direct all its energies and activity towards a definite object, in conformity with the needs of the time.

At the moment of which we speak a remarkable impetus had been given to the art of Architecture in the New World. In all directions were springing up great edifices, whose construction was, as to essential points, in accord with the cardinal principles that had come down from the early Middle Ages, while in many important respects it had been cunningly modified in an original manner rigorously adapted to the most modern requirements. Herein Tiffany saw a providential means of realising his new æsthetic visions of Decorative Art. No two arts could do better work in unison. At the same time the creators of Decorative Art were bound more than architects not to follow blindly the practice of former days. In what he did toward the beautifying of great and sumptuous habitations, our innovator was able to utilise the hieratic splendour of the orientals in a manner agreeable to contemporary tastes. He softened the boldness of Byzantine pomp into tender harmonies of colour and effect, suitable to the decoration of the apartments in which we spend the greater part of our time. Thus the walls of a spacious hall would be a sober dead

white, or finely rendered tints approximating thereto, surmounted now and then with polychrome friezes diapered with the thousand details of a cashmere design. In another place mosaic clothed the walls with warmth and sweetness, like that of silky stuffs; while on stairs, ceilings and cornices, it appeared in all its strength and brilliancy, but always preserving, both as to design and tones, an indisputably modern character. Besides being utilised in mosaic work, glass appeared in indoor decoration, in the form of windows and lighting devices; wherever, in fact, its sparkling reflections might add a joyous note to the play of light.

But before all and above all it was coloured glass that occupied the first place in Tiffany's researches. For a long time, indeed, his mind had been engrossed by the study of an important problem; namely, the discovery of a means of restoring to stained glass that purity and brilliancy the secret of which appeared to have been lost during a long series of centuries. He found that, even in the best modern specimens, the workmanship of the glass craftsman was not equal to that of the designer, each of the two collaborators being too closely mindful of his own particular task to labour in full sympathy with the other, so as to produce a homogeneous piece of work. Besides, when Tiffany considered the impressive richness of the stained glass seen in some of the Gothic cathedrals, the materials used in the present day were in comparison extremely weak, without consistency or scintillating power. Then, added to cold transparency, in which poverty of colour alternated with a shocking hardness, there was another and still worse defect. It had long been the custom to intercept the vibrations of

82 and 83. Two Tiffany Glass Vases Purchased in 1895 from
Samuel Bing by the Musée des Arts Décoratifs in Paris.
Courtesy of the Musée des Arts Décoratifs.

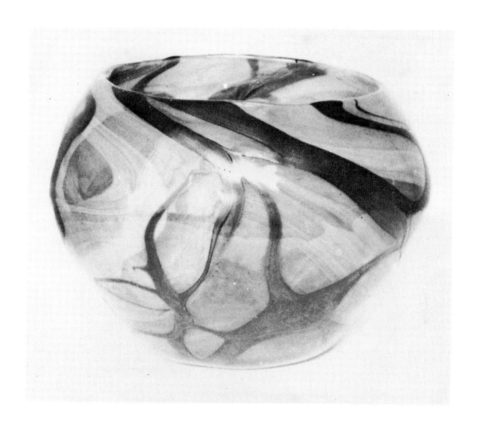

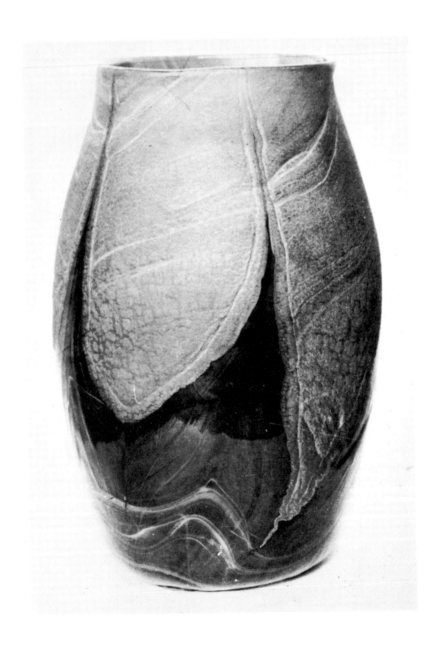

light by the application of pigments with a brush, thus dulling the material instead of enriching it. This was painting upon glass, not the creation of a picture from the vitreous substance itself by the juxtaposition of pieces, each one transfused with the colour appropriate to it, throughout its entire thickness.

This latter system was the one always employed up to the twelfth century, when the abuse, of painting upon glass, began to prevail. The decorative requirements of the Middle Ages were less exacting than is the case in modern times; the primitive simplicity which suited the old cathedrals scarcely sufficed for our *blasé* eyes, especially when the stained glass was intended to be an element of household decoration. Consequently, when something more than simple lines was needed, when it was desired to reproduce studies in the round, with strong reliefs and contrasts of light and shade, new resources had to be drawn upon and means of expression found which our ancestors had never needed. For years Tiffany gave himself up to these engrossing researches, and gradually succeeded in making a glass which answered the requirements to a wonderful degree. By the blending of colour he causes the sheet of glass to convey the effect of a cloudy sky, or of rippling water, or again the delicate shades of flowers and foliage. For drapery, in all its truth of suppleness and outline, he operates in a most ingenious manner upon the material while it is cooling, putting into it an infinite variety of folds and wrinkles. Even then he has not done perfecting, but can communicate to the glass quite a special plastic surface. New tones are to be found on his palette, and he has quite new processes, as for instance the

superposition of several plates of different colours, by which the aspect of the work is changed in the most unexpected ways.

Having thus created a material which is admirable in every respect, possessing qualities quite unknown till now, Tiffany gave it the name of "Favrile Glass," and proposed to use it for other purposes than the making of stained-glass windows. His great ambition was to employ it in the manufacture of *objets d'art.*

In view of the prestige of the old Venetian glassware, so elegant as to outline, but somewhat too frail and artificial; after the delicate jewellery of the Chinese glassworkers, who treated their curious material as they would the rarest cameos; after the wonderful progress realised in vitreous art in Bohemia; after the astonishing work produced by Emile Gallé; in presence of all these marvels, could inventive genius be expected to go farther?

Not for an instant did the idea occur to Tiffany to seek to excel in regard to florid ornament or patient labour; his plan was quite different from that hitherto adopted; he sought to go back to the primitive starting-point, and inaugurate a school, in which the supreme refinement of taste and learned technique should be concealed under the most modest exterior; everything should have the ease and softness and spontaneity of Nature herself. He showed us the delightfully soft effect produced by semi-opaque tints, in which were found, amalgamated with the vitreous material, fine veins and filaments, and blushes of colour similar to the delicate shades observable in the skin of fruit, the petal of the flower, and in the "sere and yellow leaf." And in the artist's hands there grew vegetable, fruit, and flower forms, all which,

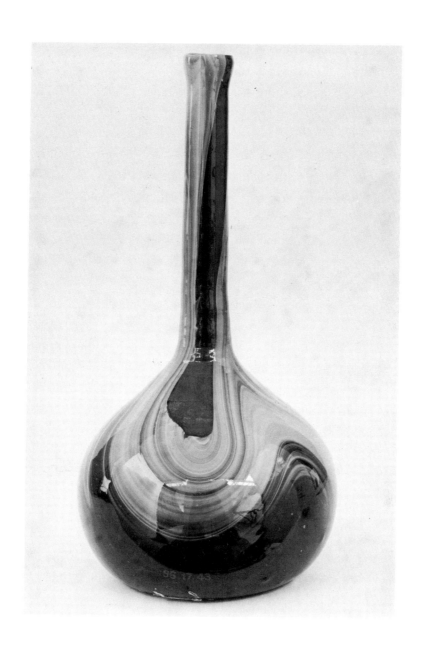

203

while not copied from Nature in a servile manner, gave one the impression of real growth and life.

Other examples showed a different order of *motifs*. Tiffany denied that the vitreous substance should always be used exclusively as a medium for the filtration of light, on pretence that tradition had so willed it. He maintained that the artist might invest his material with another and different character, provided he did not imitate any other substance with it. Wherefore he created certain kinds of opaque and opalescent glasses, the beauty of which resided in their incomparably smooth surfaces, exquisitely soft to the touch, giving the impression of a delicate silky epidermis.

But Tiffany had no sooner overcome one difficulty than he attacked a fresh problem. From infancy his colourist's eye had passionately loved the rich effects produced in antique glass in the course of centuries. While as yet almost a child, he had greedily sought for a few of these magic relics of the past, and his search was greatly facilitated by his father's position. Even now, on crossing the threshold of Louis Tiffany's habitation, the visitor pauses to marvel in presence of an incomparable spectacle: a large panel forming the back of the fireplace, and entirely made up of little pieces of antique glass, forms a mosaic, the like of which never was seen, whose pieces, all of irregular shape, are let into a leaden framework, similar to that of a stained-glass window.

And now that he felt he exercised mastery over the material, the idea occurred to him to create, by his art, beauties analogous to those which, up till then, had been produced very crudely,

85. Tiffany Glass Vase of 1897 in the Landesmuseum,
Darmstadt, Germany.
Courtesy of the Landesmuseum, Darmstadt.

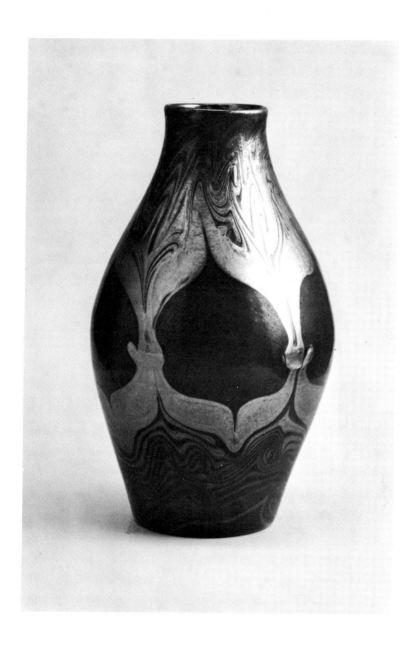

except by the fortuitous action of time. Long and patiently did he labour before securing the result of his discoveries, but at last he did attain a definite result. Far from recalling in any aspect the hard and superficial reflected lights of which certain glassworkers and ceramists seemed to be so proud, and which were only the easy product of a vulgar taste, the iridescent effects obtained by Tiffany were refined to a supreme degree. They captivated the eye by reason of their wonderful *mat* softness, and, at the same time, of a nacreous richness over which played, according to the breaking of the light, an infinite variety of tones, and wherein were opalised radiations, so subtle, delicate, and mysterious, that the water of an exquisite pearl can alone be compared to them. Herein was incarnated all the resurrected beauty of the antique glasswork, with the superadded conviction to the connoisseur that the irradiating effect was not given in this case by a change in the substance through disintegration, but that all we can see formed an integral part of the article, and was solid and firm to the touch.

The process by which this result is obtained can be easily explained. The glass, while still hot, is exposed to the fumes produced by different metals vaporised. Evidently nothing could be simpler in principle; the secret resides in the artistic brain and cunning hand of him who performs the operation.

At the culminating-point, where the present century succeeded to the possession of the old culture, which, after climbing step by step up the ladder of Art, was hampered as to future achievements with the vast accumulation of knowledge bequeathed by our earlier ancestors, it has become difficult to propound any art princi-

85. Tiffany Glass Vase of 1897 in the Landesmuseum,
Darmstadt, Germany.
Courtesy of the Landesmuseum, Darmstadt.

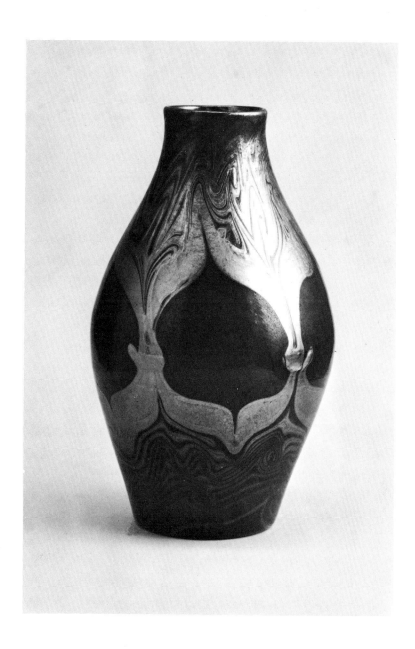

except by the fortuitous action of time. Long and patiently did he labour before securing the result of his discoveries, but at last he did attain a definite result. Far from recalling in any aspect the hard and superficial reflected lights of which certain glassworkers and ceramists seemed to be so proud, and which were only the easy product of a vulgar taste, the iridescent effects obtained by Tiffany were refined to a supreme degree. They captivated the eye by reason of their wonderful *mat* softness, and, at the same time, of a nacreous richness over which played, according to the breaking of the light, an infinite variety of tones, and wherein were opalised radiations, so subtle, delicate, and mysterious, that the water of an exquisite pearl can alone be compared to them. Herein was incarnated all the resurrected beauty of the antique glasswork, with the superadded conviction to the connoisseur that the irradiating effect was not given in this case by a change in the substance through disintegration, but that all we can see formed an integral part of the article, and was solid and firm to the touch.

The process by which this result is obtained can be easily explained. The glass, while still hot, is exposed to the fumes produced by different metals vaporised. Evidently nothing could be simpler in principle; the secret resides in the artistic brain and cunning hand of him who performs the operation.

At the culminating-point, where the present century succeeded to the possession of the old culture, which, after climbing step by step up the ladder of Art, was hampered as to future achievements with the vast accumulation of knowledge bequeathed by our earlier ancestors, it has become difficult to propound any art princi-

86. Tiffany's Display in the United States Pavilion of
the "Exposition Universelle," Paris, 1900.
Original photograph by V. de Szepessy in the
Koch Collection, gift of J. Jonathan Joseph.

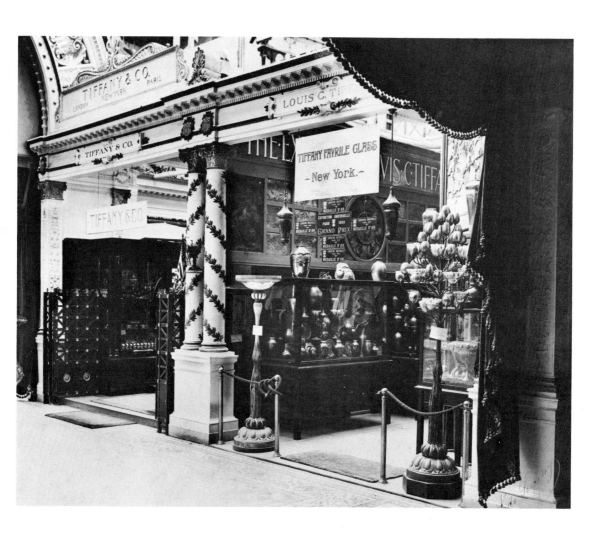

ples that shall be entirely free from the prejudices of past times. The ambition of our epoch ought to be confined to the development, in a different and progressive sense, of the beautiful growths of former ages. We have seen how, in the vitreous art, Tiffany turned to good account the examples handed down from antiquity.

Every one knows what a charming effect is produced in Murano's glasswork by the innumerable ornamental lines that striate the material in all directions. They take the most picturesque forms when manipulated by the glassblower. Tiffany, owing to his superior science, more fertile imagination and better taste, was able to secure effects of which none of his predecessors had ever dreamed. He controls chance to the interpretation of his own fancy.

Look at the incandescent ball of glass as it comes out of the furnace; it is slightly dilated by an initial inspiration of air. The workman charges it at certain pre-arranged points with small quantities of glass, of different textures and different colours, and in the operation is hidden the germ of the intended ornamentation. The little ball is then returned to the fire to be heated. Again it is subjected to a similar treatment (the process being sometimes repeated as many as twenty times), and, when all the different glasses have been combined and manipulated in different ways, and the article has been brought to its definite state as to form and dimensions, it presents the following appearance: The *motifs* introduced into the ball when it was small have grown with the vase itself, but in differing proportions; they have lengthened or

87. Glassworkers with a Press in Tiffany Furnaces,
Corona, Long Island, New York.
Courtesy of the late Jimmy Stewart. (Stewart was
employed by Tiffany as a glassman from 1895 until 1928.)

88. Glassblower in Tiffany Furnaces.
Courtesy of the late Jimmy Stewart.

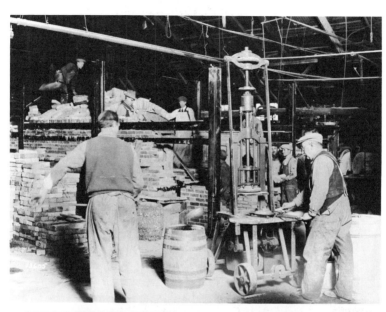

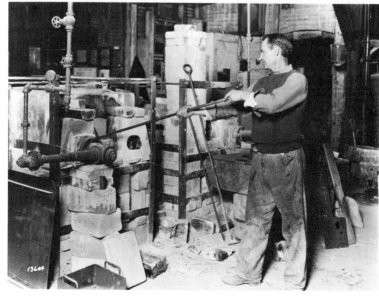

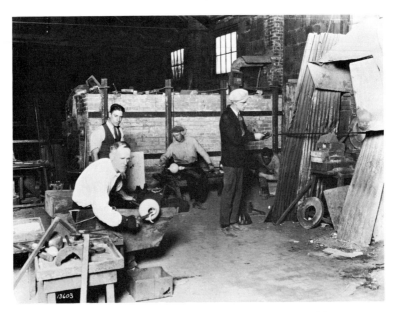

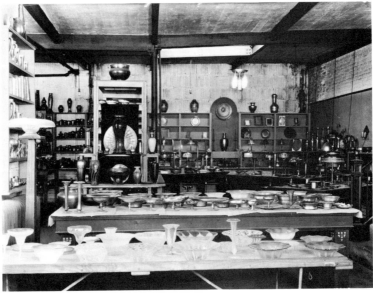

89. Glassmen at Work in Tiffany Furnaces.
Courtesy of the late Jimmy Stewart.

90. Tiffany Glass on Display at the Corona Showroom
of Tiffany Furnaces.
Courtesy of the late Jimmy Stewart.

broadened out, while each tiny ornament fills the place assigned to it in advance in the mind of the artist.

For some years already Tiffany had been able to produce in this way the veining of leaves, the outlines of the petals of flowers. In the material there flowed meandering waters and fantastic cloud forms. But he was only waiting the opportunity to apply his process on a more intricate scale. Having, at the instance of an amateur friend, sought to produce in coloured glass the peacock in all the glory of his plumage, he saw in this *motif* a theme admirably adapted to enable him to display his skill in glass-blowing—the peacock's feather. For a whole year he pursued his studies with feverish activity, and when at last a large group of vases had been completed embodying this ideal adornment, no two of which were alike, the result was a dazzling revelation.

Just as in the natural feather itself, we find here a suggestion of the impalpable, the tenuity of the fronds and their pliability— all this intimately incorporated with the texture of the substance which serves as background for the ornament. Never, perhaps, has any man carried to greater perfection the art of faithfully rendering Nature in her most seductive aspects, while subjecting her with so much sagacity to the wholesome canons of decoration. And, on the other hand, this power which the artist possesses of assigning in advance to each morsel of glass, whatever its colour or chemical composition, the exact place which it is to occupy when the article leaves the glassblower's hands—this truly unique art is combined in these peacocks' feathers with the charm of iridescence which bathes the subtle and velvety ornamentation with an almost supernatural light.

If, in conclusion, we are called upon to declare the supreme characteristic of this glasswork, the essential trait that entitles it to be considered as marking an evolution in the art, we would say it resides in the fact that the means employed for the purpose of ornamentation, even the richest and most complicated, are sought and found in the vitreous substance itself, without the use of either brush, wheel, or acid. When cool, the article is finished.

(Translator not known)

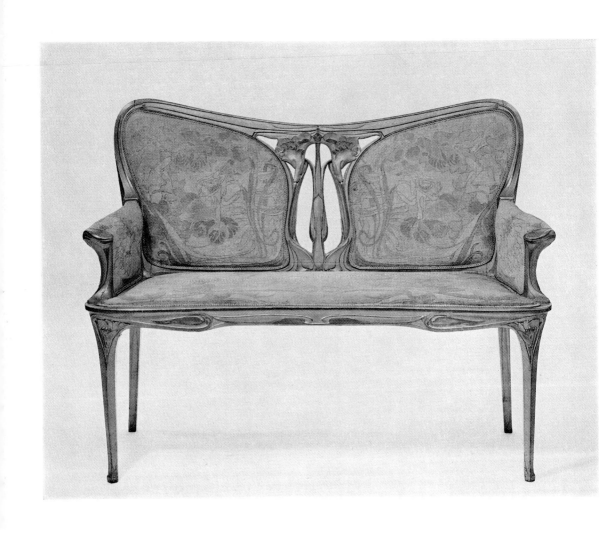

Georges de Feure, Sofa for the Boudoir in
Art Nouveau Bing, Paris Exposition of 1900.
Courtesy of the Museum of Decorative Art, Copenhagen.

III
L'Art Nouveau
S. Bing

[*"L'Art Nouveau"* is the name given by the writer of this article, M. S. Bing, to his establishment at No. 22 Rue de Provence, Paris, of which we reproduce a photograph of the principal hall. It is at this establishment that the first expositions of *Art Nouveau* have been held, and one can see there some interesting modern articles of the most varied kind—such as furniture, stuffs, jewelry, pottery, carpets, china, lamps, etc., etc. At the Paris Universal Exposition of 1900, M. Bing's exhibit of *Art Nouveau*—of which term, by the way, he is the creator and holds, so to speak, the copyright—was the most interesting one in its section, and the articles exhibited were purchased by the principal European governments in order to be placed in the national museums.—Ed.]

A few months ago I received by mail from the United States a prospectus issued by the inventor of a new machine—viz., "a machine for making *Art Nouveau*" (the last two words in French). I shall always regret not having preserved this precious document, or at least noted the name of its ingenious author; no doubt he would have been able to supply us with much information on the subject we are treating, since it has led him to the length of inventing a machine for turning out *Art Nouveau.*

After all, it is better, perhaps, that the name of my worthy correspondent should not be known, for he will thus serve as the incarnation of all those who form a fantastic idea of *Art Nouveau*—an idea based either upon certain extravagant criticisms they have read, or upon a view of those tentaculated, distorted, inharmonious objects which have been dubbed with this name in order to give them an "up-to-date" air. It is evidently from these criticisms and these objects that our inventor has acquired his knowledge, for in order to convey to his clients an exact notion

From *The Architectural Record* Volume 12 (1902), pp. 279–285.

of what the words *Art Nouveau* mean he adds this expressive definition: "French Twist."

At the risk of displeasing the collectors of curious legends I seize the present occasion to relate the origin of this term *Art Nouveau*, upon which too much ridicule has been cast, and which, at the same time, has been exploited to wrong ends.

A word is nothing in itself. It chiefly represents the meaning which its author intended to give it. In the present instance this meaning has been entirely misunderstood by certain simple persons, misled by witty individuals who did not know what they were talking about. These clever people have managed to discover an intention to originate some sort of spontaneous generation in art, founded on æsthetics altogether invented—or fallen from the moon!

L'Art Nouveau, at the time of its creation, did not aspire in any way to the honor of becoming a generic term. It was simply the name of an establishment opened as a meeting ground for all ardent young spirits anxious to manifest the modernness of their tendencies, and open also to all lovers of art who desired to see the working of the hitherto unrevealed forces of our day.

Thus the term was nothing but a title, a name, or, if you like, a sign, incapable of expressing in the two words composing it the idea which called it forth, the aim to which it tended. This idea, this aim, would be indicated more clearly—if the name of an establishment could extend to the length of a phrase—by the denomination: *Le Renouveau dans l'Art*—the Revival of Art. Even this might not suffice without commentaries. Let us try to fill the blank.

In certain branches of art, such as painting, for example, which has steadily continued its development in a normal and regular way, no revival was called for. It was only in relation to art as applied to decoration, to furniture, to ornamentation in all its forms, that the need of a new departure was felt. This department of art, in reality the most essential to man, being closely connected with his daily existence, had been at a standstill for nearly a hundred years. By a singular exception to the logical course of things, all the life had gone out of this section of human activity. It was not the repose of the Sleeping Beauty, for all around there was busy movement and constant progress, due to the quickening effect of a thousand scientific discoveries and the shake-up caused by social innovations of the most radical kind. Amidst this universal upheaval the decoration of the day continued to be copied from that in vogue in previous centuries, when different habits and different manners were current. What an astonishing anachronism!

It is difficult to conceive how several successive generations could have abandoned themselves to this inertia. However, it was impossible that the world should forever acquiesce in an avowal of such humiliating impotence. Little by little voices were raised in protest and signs of an awakening began to appear. What was lacking was a means of stimulating artists to new efforts, of establishing some connection between isolated endeavors, and of providing a suitable place for displaying the latter and submitting them to the judgment of the public.

In the beginning I confined myself to this rôle of intermediary —of standard bearer in the service of the good cause. Soon,

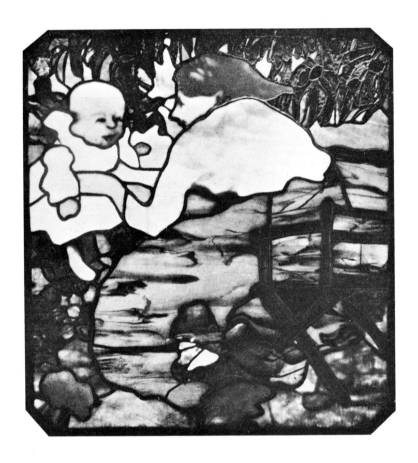

91. Pierre Bonnard and Louis C. Tiffany, *Mother and
Child* Window Displayed at the Paris Salon in 1895 and
Acquired by Samuel Bing for the Salon de l'Art Nouveau.
From *Dekorative Kunst*, 1898.

however, the disillusion came. The productions gathered together in my establishment had a chaotic appearance. Many were faulty in conception, due to inexperience: all suffered in their aspect from a want of cohesion, due to extreme diversity of origin. The general defect was a premeditated contempt for that quality which is indispensable in a work intended to rest the eye—simplicity.

It was evident that the future of this new-born movement was in great danger. The only way to save it from total collapse was to endeavor to make it follow a fixed direction, carefully marked out; to keep it within the bounds of sobriety and good sense, avoiding the extravagances of exuberant imaginations and relying for its salvation upon these two fundamental rules. *Each article to be strictly adapted to its proper purpose; harmonies to be sought for in lines and color.* It was necessary to resist the mad idea of throwing off all associations with the past, and to proclaim that, on the contrary, everything produced by your predecessors is an example for us, not, assuredly, for its form to be servilely copied, but in order that the spirit which animated the authors should give us inspiration. Things which we call ancient were supremely modern at the time they were made. To none of our ancestors would it have occurred to look backward for the purpose of repeating what artists of former periods had invented to suit the habits and customs of their own day; but neither would he have tried to do anything more than take up the work at the point where his predecessor had left it, and in his turn develop it logically to meet the general spirit of the age in which he was living.

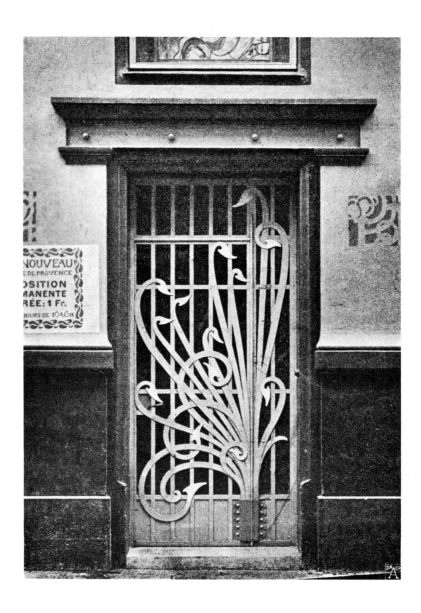

92. Louis Bonnier, Exterior Door of the
Salon de l'Art Nouveau, Paris, 1895.
From *Dekorative Kunst*, 1898.

93. Louis Bonnier, Interior Balcony in the
Salon de l'Art Nouveau, Paris, 1895.
From *Dekorative Kunst*, 1898.

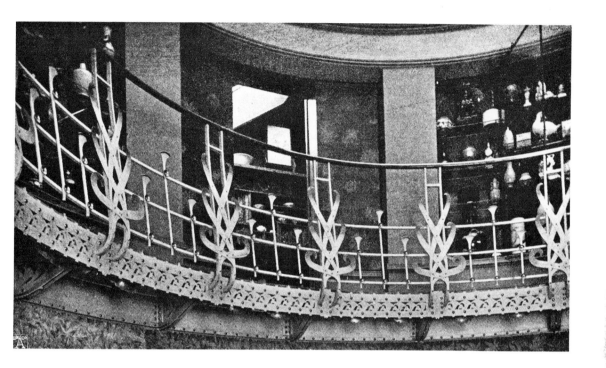

There was only one way in which these theories could be put into practice—namely, by having the articles made under my personal direction, and securing the assistance of such artists as seemed best disposed to carry out my ideas. The thousand ill-assorted things that I had collected together in a haphazard way gave place, little by little, to articles produced in my own work-shops, according to the following program, to the exclusion of all other considerations. Thoroughly impregnate oneself anew with the old French tradition; try to pick up the thread of that tradition, with all its grace, elegance, sound logic and purity, and give it new developments, just as if the thread had not been broken for nearly a century; strive to realize what our distant predecessors would do if they were alive to-day—that is, enrich the old patrimony with a spirit of modernness, bearing in mind the eternal law which ordains that everything which fails to keep progressing is doomed to perish.

Far be it from me to imagine that nothing good can be produced except in the way which I conceive to be the right one. In the wide field now open each of us can sow his seed according to the fruits he wishes to gather. The only danger lies in the growth of rank weeds, impudently thrusting themselves to the front and choking the tender young plants just springing up. By "rank weeds" I mean all those crude imitations, shaped without regard to the most elementary rules of logic and given the name of "Art Nouveau;" all that parasitic vegetation which, as yet, prevents hesitating spirits from seeing that the time has come for us to shake off our foolish inertia, and that there is now no longer any

reason why our decorative arts should not recover their full free-
dom of expansion and flourish as gloriously as they did in former
times.

Translator unknown

IV
L'Art Nouveau

S. Bing

Translated from the French by
Irene Sargent

L'Art Nouveau*

The Craftsman having decided to open its columns to a discussion of "L'Art Nouveau: its Significance and Value," the initial article appeared in December, 1902, over the signature of Professor A. D. F. Hamlin of Columbia University. This article actuated a reply from M. Jean Schopfer of Paris, which was published in the June issue, 1903. And now it would seem fitting, before closing the debate, to hear the argument of the one who, eight years since, had the good fortune of aiding the latent aspirations of the period to assume a visible existence, and of serving as sponsor to the new life.

The article of Professor Hamlin is without doubt one of the most conscientious and impartial studies of the question that have yet appeared. I am, however, far from sharing all the ideas of the writer, and, although some points have already found an eloquent opponent in M. Schopfer, I willingly again revert to them.

To begin: I fully support Professor Hamlin, when he opens the discussion with the following statement:

" '*L'Art Nouveau*' is the name of a movement, not of a style; it has come into use to designate a great variety in forms and

From *The Craftsman*, Vol. V, October 1903, No. 1.

* In the year 1895, the writer of these pages founded in the rue de Provence, Paris, a center open to all the forces of artistic innovation. In order to designate the tendencies of this enterprise, he devised the title of *L'Art Nouveau*, without suspecting then that this combination of words would gain the doubtful honor of serving as a label for miscellaneous creations, some of which were to reach the limits of license and folly.

development of design, which have in common little, except an underlying character against the commonplace. . . ."

I interrupt the quotation at this point because I do not agree with the end of the sentence, which declares that the followers of the movement concur only in "their common hatred of the historical style."

Before presenting my objections, I must say that it appears to me illogical to apply the same scale of criticism to two sides of the question which can not be included within the same field of vision. A separate judgment must be granted to the initial principle of the movement and the infinite multiplicity of its applications, which are all individual and a forced combination of the good, the indifferent and the bad.

I. THE PRINCIPLE OF L'ART NOUVEAU

Is it accurate to say that no definite aim has been generated by *L'Art Nouveau,* and that its disciples are united only by a negation? The truth is this: that no definite style was prescribed, since the work to be done was a work of liberation. The title of *L'Art Nouveau* designated a field lying outside the narrow boundaries within which, beneath the pressure of a time-honored slavery, a class of degenerate products was approaching extinction. It designated a free soil upon which any one could build according to his own desires. Therefore, there was no pre-conceived idea, no restraint as to the form of expression. But there was, nevertheless, a common idea: differing from the one ascribed to the followers of *L'Art Nouveau* by Professor Hamlin. The true bond between

the innovators resided in the hatred of stagnation. If, therefore, Professor Hamlin is right in speaking of a negation as the point of departure of the new movement, this negation consisted solely in an energetic protest against the hiatus which, for an entire century, had suspended animation in that branch of art. Far from proceeding as Nihilists, the initiators of *L'Art Nouveau* sought beneath the accumulated ashes of old systems the spark of that former life which had developed the arts of the people, slowly, generation after generation, from the distant cradle of human civilization down to the sudden paralysis caused by the brutal shock of the French Revolution.

Here, therefore, side by side with the departure "from a fixed point" there is a first step "toward one:" an initial agreement established in view of an "affirmative purpose," consisting in the determination not to despise the work of our predecessors, but to do what they would have done in our place: they who would never have debased themselves to counterfeit the genius of their ancestors; who would never have wished to sterilize the genius of their own generation.

But our minds being heavily burdened with old memories, how was it possible to resume the march of progress so long interrupted? Where seek a trustworthy guide? What rules were to be observed? A reversion to free Nature could alone restore and rejuvenate our spirits. From this infallible code of all the laws of beauty we were forced to ask the secret of a new advance, capable of enriching the old formulas with a new power of development. And this development it was necessary to urge forward in a man-

ner conformable to all other branches of contemporaneous aesthetics, in a manner adequate to our form of society and our actual needs. In a word, we were forced to subordinate the general character of our environment to all the conditions of modern life. It was necessary, at the same time, to restore certain essential principles which had long previously fallen into neglect. These necessities were: to subject each object to a strict system of logic relative to the use for which it is destined and to the material from which it is formed; to emphasize purely organic structure, especially in cabinet-making; to show clearly the part played by every detail in the architecture of an object; to avoid, as one would flee from leprosy, the falsehood of a fictitious luxury consisting in falsifying every materials and in carrying ornament to extremes.

Such, in essence, are the principles which formed the basis of agreement for the initiators of the movement, whose effects, during its active period, we are now to observe.

THE PRODUCTIONS OF L'ART NOUVEAU

It has seemed to me judicious not to confuse the doctrines which gave birth to *L'Art Nouveau* with the applications which have been made of it. I shall protest much more strenuously against the custom of subjecting all these productions indiscriminately to a sole and summary judgment. I do not direct my protest against Professor Hamlin, nor solely against the very limited number of other writers who have treated the question: I accuse the whole body of art critics of having, in this instance, seriously failed in professional duty. In the presence of a sudden and disconcerting

growth, in the face of the daily mounting flood of productions
contrasting not only by reason of their novelty with familiar
forms, but often also differing among themselves, the critics have
left the public absolutely without guidance. The special publica-
tions devoted to applied art, which arose in great number, had no
object other than to make pass in review before the eyes of the
reader (it were better to say the spectator), after the manner of
a kaleidoscope, in a chance order of appearance, the assemblage
of all new efforts, whether more or less successful. But among
those who assumed the somewhat grave responsibility of instruct-
ing the public regarding the artistic phenomena of each day,
among those even who declared with emphasis that there should
no longer be an aristocratic art, and that all artistic manifesta-
tions: painting, sculpture or the products of the industrial arts,
had equal rank, no one assumed the duty of making a serious
study of this subject,— that is, no one in position to speak with
authority. *L'Art Nouveau*, it is true, if it be considered as a whole,
has no cohesive principle. * It could not have such, when employ-
ing its activity upon a virgin soil, in a field where every one was
bound to display his individual temperament. But in the midst of
the myriad attempts whose tangled skein can not be straightened
by the layman, we, the critics, point out certain efforts, each one
of which in the respect that concerns it, converges toward a defi-
nite ideal, an aim clearly perceived. We say: Reject the mass of

* In order not to extend unduly the length of this article, I must set aside architecture,
which, it must be said, has not sufficiently acknowledged the progress of other
branches of art which it should have assisted, since it had not, as leader and chief,
been able to guide them by a bold initiative.

94. George Lemmen, Advertisement for Samuel Bing.
From *Dekorative Kunst*, 1898.

worthless efforts, eliminate all abortive work, imitations, and commercial products, but save from irreparable destruction anything that can contribute, though it were only as a very germ, to future fertility, if you do not intend to pronounce death sentence upon all those of our faculties whose exercise beautifies our dwellings!

It is not to be expected that I should produce in these pages an extended critical work. Not only would my militant attitude in the question prevent me from such audacity, but such an endeavor would considerably exceed the limits of the present plan. I shall content myself with making here a rapid examination of the path followed by *L'Art Nouveau:* beginning with its first general manifestation, which, as I have previously stated, occurred in 1895, in the galleries of the *Rue de Provence,* Paris.

It would be difficult to say which, for the moment, triumphed in this fateful struggle—the chorus of approval, or the cries of indignation. The fact remains that the impression then made was powerful enough to create a large following of recruits, impatient to enroll themselves beneath the banner displayed by the vanguard. Unhappily, it is much easier to submit a new order of productions to public examination than to make the public understand the reasons which governed the creation of such objects and prescribed to them their forms. The adepts of the second hour were divided into different classes. There were artists, sculptors or painters whose somewhat vagabond imagination was more familiar with dreams and poetry than with practical ideas. They designed tables supported by nymphs with soft, sinuous bodies,

234

or by strange figures savage in their symbolism, with muscles swollen and writhing under efforts which had no sign of humanity. There were also young middle class women who abandoned the needle, the crochet-hook and the piano, that they might pyrograve leather, or hammer copper into works which were almost touching in their artistic poverty: all these being, of course, more or less sedative and too restricted in their reach to compromise seriously the good cause and prevent its progress. The dangerous evil: that which could strike at the vital part of the idea, and possibly occasion its utter failure, was to arise elsewhere.

Throughout the course of history no epoch-making idea of idealistic tendencies has ever arisen, which has not been quickly counterfeited by the army of profit-seekers who have enrolled themselves beneath its banner to protect their purely mercantile schemes. But never, perhaps, has this phenomenon been so strikingly instanced as in the case in point. Owing to the feeble state of certain industries, as, for example, that of cabinet-making, an opportunity was afforded to profit by the effect produced by the rise of *L'Art Nouveau.* But it must not be believed that, spurred by this impulse, the leaders of industry set themselves without loss of time to a deep study of the necessary principles. Far from that! Nothing, in their minds, was more easy than to produce *L'Art Nouveau*, since that, according to their point of view, must be simply the art of improvising something else than the works of yesterday. They therefore gave the pencil into the hands of their designers with orders to trace upon the paper outlines interlacing in all directions, writhing into fantastic expansions, meeting in

234
L'Art Nouveau

snail-spirals, framing asymmetrical panels within which bloomed the reproduction of some natural growth, exact to the point of photography. In fact, it was not difficult to produce *L'Art Nouveau* of this species. Nor was it costly, since it required neither preliminary studies, nor the use of valuable material, nor great care in execution. The product was abundant, too abundant, and the public, accepting the name for the thing in itself, did not hesitate to accept this product under the official title which assured its success. It need not be explained that the more eccentric it was, the more quickly it was received as *L'Art Nouveau*. I might—but I refrain—cite the instance of a museum, the most famous of its class, whose representative selected for his collections a coffer overburdened with fantastic floriated ornament, preferably to a wardrobe full of symmetrical grace; explaining meanwhile that the character of the latter piece was not sufficiently accentuated to deserve the name of *L'Art Nouveau*.

But slowly, vision having grown more experienced and critical, begins to distinguish the true from the false. In the midst of the obscuring chaos, there are discernible clear ideals of art tending toward a definite purpose. The work of elimination being complete, each one will choose the species of production that shall best adapt itself to his taste, while waiting for future generations— the supreme judges of men and things—to make final classification, according to degrees of merit. Future judges will all acknowledge the indelible mark of our epoch, without it being necessary, as Professor Hamlin would desire, for all our artists to concur in an absolute identity of style, as once they did. Such

freedom will leave a wider field open to the imagination of those who create, and will permit each individual to impress his personality upon the places in which he passes his life. Far from regretting this variety in the forms of expression, let us enjoy the proffered riches, and let us now seek to acquaint ourselves with the origin and the nature of these divergences as well as to compare their merit.

Two principal and parallel currents can be discerned in the direction of the movement: the system of purely ornamental lines already indicated by Professor Hamlin, and the system of floral elements; each of the two systems having fervent champions and active detractors. In every new cause it is well that uncompromising elements arise, exaggerating partial virtues, which later, wisely proportioned, unite in a definitive, well-balanced whole. The divergence in the first phases of *L'Art Nouveau* are attributable less to questions of individual temperament than to questions of race. In these first phases, the principal part was not played by the country which had long occupied the first place in European decorative art. France remained attached with what might almost be termed patriotic tenderness to traditions whose roots struck into the lowest depths of the soil of the fatherland.

The initial movement, as Professor Hamlin himself observes, began in England, under the influence of the Pre-Raphaelites and the ideas of Ruskin, and was carried into practical affairs by the admirable genius of William Morris. But if insurrection arose then against the frightful ugliness of contemporary productions, it did not declare the imperative need of a renewal of youth conforma-

ble to the modern spirit. Highly aristocratic natures, who would willingly have witnessed the destruction of railways guilty of killing the beauty of the landscape—such as these necessarily produced works echoing the art of primitive times dominated by the poetry of an abstract dream. They projected over the world a soft light, full of charm indeed, but which, as a distant reflection of extinct suns, could not have a prolonged existence, nor even a warmth sufficient to light new centers. This episode will remain in the history of art as an attractive chapter too rapidly closed. Latterly, England has taken a new direction under the guidance of numerous artists, the most noted of whom are mentioned by Professor Hamlin. Among them only a fraction are faithful to the Morris traditions.

To Belgium belongs in all justice the honor of having first devised truly modern formulas for the interior decoration of European dwellings. *

In the year 1894 there was founded at Brussels, under the guidance of M. Octave Maus, a society of artists designated as *La libre Esthétique,* having as its object to assemble in an annual exhibition all works of essentially modern character. This was the first occasion when the aristocratic arts of painting and sculpture admitted without blushing to their companionship the commonalty of industrial productions. Already there appeared manifestations of a real value, the outcome of reflective minds steadily pursuing individual aims. I have always retained a most favorable

* Professor Hamlin rightfully says: "Its tendencies are for the present divergent and separative."

memory of certain model tenements exhibited at *La libre Esthé-tique* by Serrurier-Bovy of Liège, who had succeeded in uniting with a low net cost all desirable requisites of beauty, hygiene and comfort. But the man sufficiently gifted to engender really bold ideas and to realize them in all the perfection permitted by their species, was Henri van de Velde, professor of aesthetics at one of the free institutions at Brussels. He executed in 1895 for the establishment of *L'Art Nouveau,* Paris, a series of interiors, which he followed by other works exhibited at Dresden in 1897, and which not only constituted in Europe the first important examples (*ensembles*) of modern decorative art, but have since remained the most perfect types of the species. This species was the development of the line—the decorative line shown in its full and single power.

The cradle of this species of art was, therefore, Belgium, the country belonging to the Flemish race, whose tranquil and positive mind demanded an art of austere character adapted to patriarchal customs: hostile to the principles of the light fancy which willingly takes inspiration from the slender grace of the flower. If, through an apparent failure in logic, France served as the stage for the first appearance of an art so little French in its essence, it was because at that time, only eight years since, there was as yet nothing beside it; no conception sufficiently mature to serve the projected uprisal which had as its first aim to sound the awakening call, while waiting to give later an impetus and aim more conformable to the national spirit.

In Germany, the situation, for several reasons, was altogether

95. Henry van de Velde, Furnishings for a Study,
Displayed at the Munich Secession in 1899.
From *Dekorative Kunst*, 1900.

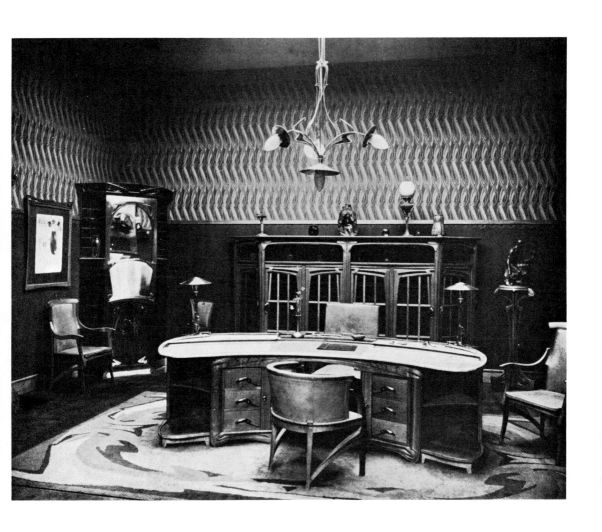

different. First, a close relationship unites the German with the Flemish character. Further, it must be recognized that Germany, long wanting in intuition, has always shown a great receptivity toward all external influences. Now, the novelty shown in the exhibits of *L'Art Nouveau,* Paris, at the Dresden Exposition of 1897, produced an impression strong enough to be echoed throughout Germany: this was the real point of departure for the German *Art Nouveau,* to the development of which, van de Velde, afterward called into the country, himself contributed. Austria, who, in previous years, had madly abandoned herself to a sort of art for exportation devised by England for the use of the unthinking masses of the continent, followed, in her turn, the same path. By a kind of fatal law all imitators seem condemned to an impulse of exaggeration, which changes into shocking defects all doubtful portions and details of the model. It was thus that in Germany and especially in Austria the insistent scourge of tortured, swollen and tentacular lines grew more and more aggravated, thus causing an abuse most harmful to the reputation of *L'Art Nouveau.* Artists of solid worth have, nevertheless, arisen in the Teutonic countries, but they have need of casting off the foreign *impedimenta* which weights their inspiration and occasions the cruel errors by which the taste of Professor Hamlin is so justly offended in presence of the works of the Darmstadt colony: a body now dispersed.

To sum up, we may say that combinations purely linear permit the designer to obtain, particularly in cabinet-making, broad and robust effects, a clear and logical structural arrangement. The

reverse of these qualities, if they are formulated into intangible and exclusive rules, gives rise to a monotony which does not delay its appearance. Quickly the artist reaches the limits of his possibilities, inspiration ceases, and astonishment arises at the fact that all power was expended in the initial effort.

At such a moment it is evident that a return to Divine Nature, always fresh and new in her counsels, can solely and incessantly restore failing inspiration. In reviewing the history of the decorative arts in France, one will remark that always the artists of this country, with the exception of those of the sixteenth and a part of the seventeenth century, have had an acute sense of this truth. By receiving inspiration from these lovers of nature, the artists of our own time will accomplish each day more happily a difficult task which they alone, perhaps, are capable of fulfilling. The work before them consists in fusing into a harmonious whole the two apparently hostile principles of robustness and grace: the solid and crude art asserted by the Northern countries, and the delicate refinement peculiar to the Latin races; it consists in giving prominence to the strongest structural laws with a constant regard for practical results; but, at the same time, in banishing all heaviness of effect, all sterility of line, and, if the limits of value permit, in adding a flavor of fine elegance; it consists, in a word, in satisfying the demands of strict logic, in providing pleasure for the eye, and even in inviting the caress of the touch. Thus will France prove that, during her long sleep, she has not allowed the qualities with which Nature so generously endowed her to fall into decline.

But the influence of France will never again dominate the

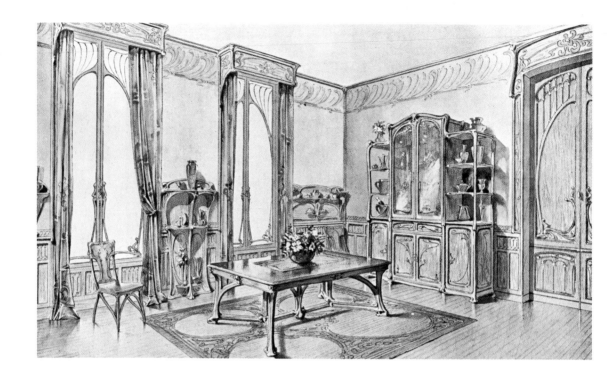

96. Eugène Gaillard, Drawing for the Dining Room of
Art Nouveau Bing, Paris, 1900.
From *Dekorative Kunst*, 1900.

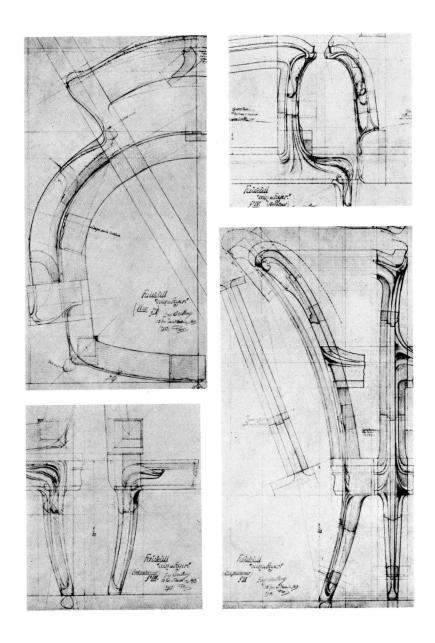

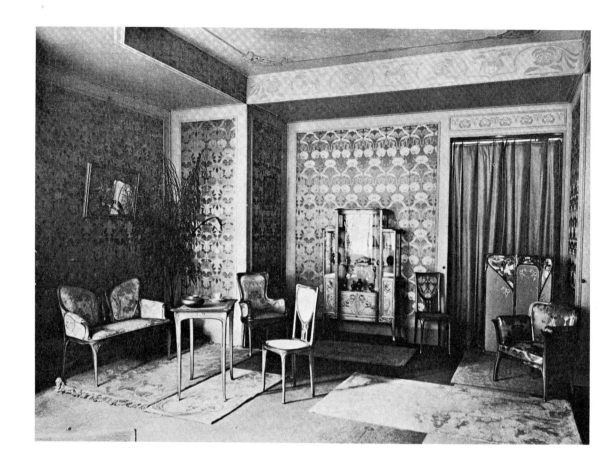

98. Georges de Feure, Boudoir in Art Nouveau Bing,
Paris, 1900.
From *Dekorative Kunst*, 1900.

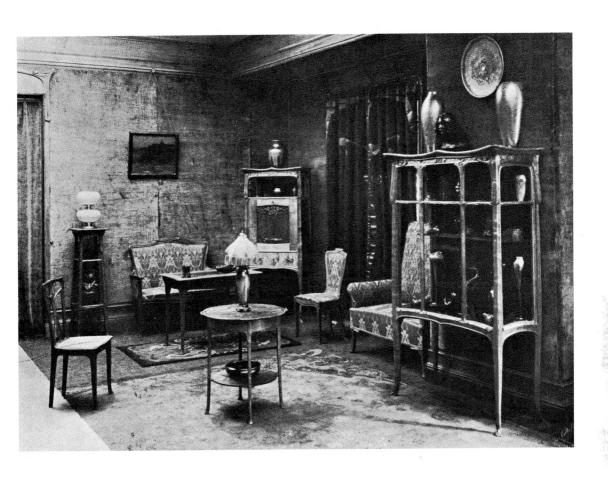

world so completely as in former times. As communication between the different nations becomes easy and constant, as frontiers grow nearer, and the exchange of ideas multiplies, one may imagine each separate people as fearing lest the formidable leveling wind that is now passing over the world, seize and carry away the last traces of independence. As one retires from the great central fires of humanity, lesser flames start upward with fuller impetus and force.

We have seen Belgium set up within her narrow limits an art possessing a distinct savor of the soil, but still an art of somewhat broad characteristics. Beyond her frontier, Holland, on the contrary, engendered, a decade since, a local style extremely accentuated, revealing at times beauties too striking not to deserve mention in every study of the present movement and development. It is the more necessary to speak of these works for the reason that they are little known to the outside world. Not only does their strictly national character, strongly marked with ancestral Javanese influence, predestine them to local adaptations within the frontier limits, but it must be added that the greater number of Dutch artists show a mysterious and singular disdain for cosmopolitan reputation. There is now in Holland a large constellation of talents which deserves the honor of a monograph. But let it suffice here to cite as especially worthy of mention the names of Dysselhof, Toorup, Thorn-Prikker and Huytema.

Mounting higher toward the North, we find Denmark, who, beside her celebrated porcelains, has developed in all branches of her art, under the wise direction of Pietro Krohn, the affable cu-

rator of the Museum of Decorative Arts, Copenhagen, a national growth: a style extremely pure in its robustness. Still farther Northward, Sweden and Norway have participated no less ardently in the universal impulse toward a renewal of the ancient Scandinavian art, revived without essential weakening of its original character.

Finally, it would be wanting in strict duty to pass over in silence a similar movement of the highest interest which has been observed for several years on the extreme limits of Northern Europe: that is to say, in Russia. There, in the midst of a peasant population of primitive manners and customs, great colonies of artworkers—weavers, embroiderers, sculptors, potters, ironworkers and cabinet-makers—have been founded under the patronage of the highest personalities of the Empire. Artists of reputation—such as Monsieur S. Malioutine and Mademoiselle Davydoff —indicate the paths and the models to be followed. The enterprise is directed with unflinching activity by ladies of the high aristocracy, among whom it is impossible not to mention the Princess Marie Ténicheff, the generous founder of the remarkable people's workshops at Talachkino, and also Madame Jakounchikoff, founder of the workshops at Smolenka, in the Government of Tamboff, a lady who, with unwearying devotion, consecrates her life to an admirable task. The productions of these colonies are not repeated and unvarying copies of old Russian models, nor are they, what one could fear still more, pretentious imitations of objects more recently created in Western Europe. There truly exists something resembling a species of Russian *Art*

Nouveau; for it is very new and, at the same time, thoroughly Russian. It is possible for these noble institutions to pass onward to a future of extraordinary possibilities, if no social catastrophe occur to destroy them.

I have waited until the end to acknowledge that America has already furnished a contribution to the universal efforts of our times, which is now sufficiently noteworthy and valuable to merit for her the esteem of all friends of art. To limit myself to my personal knowledge, I shall mention men like the deceased archeologist Moore, like John La Farge and Louis Tiffany, whom the old continent would have been proud to possess, and I shall point to industries like the American manufacturers of colored glass, the Rookwood and Grueby potteries, which have taken equal rank with the European establishments of similar character. But the branch in which the Americans have passed to immediate mastership is in the conception and execution of objects destined for practical use in household interiors. No designers have more clearly understood that the first impression of beauty, of the most essential beauty, emanates from every object which assumes the exact character of its use and purpose.

I express the conviction that America, more than any other country of the world, is the soil predestined to the most brilliant bloom of a future art which shall be vigorous and prolific. When she shall have acquired, in the province of ideal aims, a consciousness of her own possibilities, as precise and clear as the confidence already gained in other domains of intellectual force, she will quickly cast off the tutelage of the Old World, under which

100. Edward Colonna, Necklace of Gold, Enamels, and Pearls
Designed for Samuel Bing's Salon de l'Art Nouveau.
From *Dekorative Kunst*, 1900.

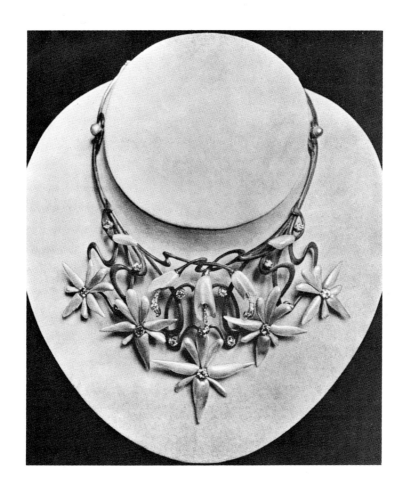

she put forth her first steps upon the sunlit path of art. America, as I have already said elsewhere, has a marked advantage over us, in that her brain is not haunted by the phantoms of memory; her young imagination can allow itself a free career, and, in fashioning objects, it does not restrict the hand to a limited number of similar and conventional movements. America, taken all in all, is indeed only a ramification of our ancient sources, and consequently the heir of our traditions. But again, she has a special destiny, occasioned by the fact that she does not possess, like us, the *cult,* the *religion* of these same traditions. Her rare privilege is to profit by our old maturity and, mingling therein the impulse of her vigorous youth, to gain advantage from all technical secrets, all devices and processes taught by the experience of centuries, and to place all this practical and proven knowledge at the service of a fresh mind which knows no other guide than the intuitions of taste and the natural laws of logic.

Editor's Note.—The editors of THE CRAFTSMAN regard themselves as most fortunate to have been able to present in the pages of their magazine an extended and just appreciation of a great art movement, concerning which there is so little definite information among the people.

In the issue of December, 1902, Professor A. D. F. Hamlin of Columbia University offered a judgment of *L'Art Nouveau,* bearing principally upon its manifestations in architecture.

This paper excited the interest of several distinguished French critics, who, while awakened to admiration by the knowledge and justice displayed by the American writer, found yet occasion to differ with his opinion that *L'Art Nouveau* was based upon a negation and tended toward no definite aim.

This opinion was opposed in the issue of July, 1903, by M. Jean Schopfer, a Parisian authority known in the United States by his writings, as well as by his repeated appearance in the lecturerooms of the Eastern universities.

M. Schopfer's article was a criticism of the *Art Nouveau* movement, judged from the historical point of view. It was calm, broad, logical and masterly: in every way calculated to remove the prejudice created in America by the vagaries of those whose

position in regard to the movement may be compared to that of the lawless camp-followers of a well-disciplined army marching to the conquest of liberty. This second article was comprehensive in its treatment and included in its survey the decorative and "lesser arts." It was, therefore, of wide general interest, and it obtained the appreciation and comment which it deserved.

The third division of the discussion just now presented bears the signature of the highly distinguished critic and patron of art, M. S. Bing of Paris. He it was who gave the name to the latest phase of modern art: watching its development from germ to bloom; seeing abortive growths fall away from the parent source of life, and other fairer types poisoned by hostile and noxious influences; but permitted at last to witness the definite success of a persistent and healthy organism, whose infancy he had wisely fostered. M. Bing's article appeals not alone to artists and those interested in æsthetic subjects: through it throbs the pulse of that modern life which is supremely creative, and capable of reducing the ideal to the real, the definite and the practical. M. Bing has proven that *L'Art Nouveau* is neither based upon a negation, nor destructive in its aims. He gives account of his sponsorship over a young cause which, a decade since, agitated within the narrow boundaries of an old Parisian street, has since spread over the world. He makes also a prophecy for the future of art in which there is no racial exclusiveness. He shows that nothing that is artistic is foreign to him.

Index